María Speaks

Critical Intercultural Communication Studies

Thomas K. Nakayama
General Editor

Vol. 5

PETER LANG
New York • Washington, D.C./Baltimore • Bern
Frankfurt am Main • Berlin • Brussels • Vienna • Oxford

SARAH AMIRA DE LA GARZA

María Speaks

Journeys into the Mysteries of the Mother in My Life as a Chicana

PETER LANG
New York • Washington, D.C./Baltimore • Bern
Frankfurt am Main • Berlin • Brussels • Vienna • Oxford

Library of Congress Cataloging-in-Publication Data

De la Garza, Sarah Amira.
María speaks: journeys into the mysteries of the Mother
in my life as a Chicana / Sarah Amira De la Garza.
p. cm. — (Critical intercultural communication studies; v. 5)
Includes bibliographical references and index.
1. De la Garza, Sarah Amira. 2. Spiritual biography—United States.
3. Mexican Americans—United States—Biography.
4. Mexican American women—United States—Biography.
5. Mary, Blessed Virgin, Saint—Devotion to—Mexico.
I. Title. II. Series.
BL73.D4A3 204'.092—dc22 2003019416
ISBN 0-8204-6701-4
ISSN 1528-6118

Bibliographic information published by **Die Deutsche Bibliothek**.
Die Deutsche Bibliothek lists this publication in the "Deutsche
Nationalbibliografie"; detailed bibliographic data is available
on the Internet at http://dnb.ddb.de/.

Cover design by Lisa Barfield
Cover art, "Sisters of Clouds," by Adriana Díaz
(acrylic on canvas, 24" x 29", © 1994; www.adrianadiaz.com)

The paper in this book meets the guidelines for permanence and durability
of the Committee on Production Guidelines for Book Longevity
of the Council of Library Resources.

© 2004 Peter Lang Publishing, Inc., New York
275 Seventh Avenue, 28th Floor, New York, NY 10001
www.peterlangusa.com

Printed in the United States of America

To my mother
Senaida Ureta González

Contents

List of Illustrations

Foreword

María Speaks is a remarkable achievement. The reader engaging this work will be challenged to seriously reconsider the relationships through which we come to knowledge. In its careful and precise presentation, *María Speaks* takes account of its own creation in ways that move us beyond the solipsist and ego-centered tendencies that often accompany extended accounts of an author's experience. This is a very important point because if we fail to recognize how De la Garza works actively against this tendency, we will never be able to fully appreciate what this work accomplishes.

Sarah Amira De la Garza is an experienced researcher of culture. Even more importantly, she is a researcher who has never allowed herself to be satisfied with the current state of understanding about how one goes about studying culture. Acutely aware of the devastating effects of colonialism on the cultures and spirits of the people of the western hemisphere over the past 500 years, De la Garza has persistently and tenaciously sought to chart a journey through the study of culture that would not replicate the cultural and spiritual genocide pursued by the colonizers. This is a very difficult goal to achieve, however, because our existence today is a colonialist existence. Our institutions of education and knowledge production are entirely rooted in the cultures of the colonizers. Thus, to study culture from a decolonialist position is very difficult to achieve as actual and material fact. In other words, despite the fact that current trends in academic work produce volumes and volumes of "postcolonial" and "decolonial" work, the critical impact of these volumes within the communities most devastated by colonialism often remains limited.

De la Garza's use of autoethnography is designed, in part, to address the problem of colonialism as it remains embedded within our normative modes of cultural research. On this point De la Garza insists that one's own life is an important source, perhaps even the most important source, of cultural insight. And here we should be clear that this claim is not suggesting that every person necessarily has equal access to cultural insight, but rather that the capacity for that insight is what is universal. Gaining access to that insight requires dedication, persistence, and tenacity. It is this practice of dedication, persistence, and tenacity that has pushed De la Garza to continue moving beyond the easy or comfortable and toward those moments and places of genuine decolonial practice and cultural insight. We should also be clear that De la Garza's multicultural heritage demands that she

journey through the meaning of Chicana and mother not as (essentialist) identity categories, but as a member of communities searching through a "smoky ancestor trail."

Although ethereal in many respects, *María Speaks* is also very concrete. In fact, it is the way in which the ethereal and the concrete live side by side within the text that is one of its most remarkable features. De la Garza's use of "deconstruction as sacred" achieves this point. In the academic world today, it is, unfortunately, too often the case that cultural criticism and deconstruction are tossed about as if they come from nowhere. That is to say that the critic him- or herself often speaks with little or no attention to the fact that the criticism comes from someone who is somewhere. In presenting the deconstructive effort as sacred, De la Garza pushes herself and the reader to foreground the fact that culture lives first and foremost within us. To make a critique of culture, therefore, requires an examination of the culture living within. Far from any kind of psychological self-immolation, the sacred practice of deconstruction must be rooted in a profound sense of respect and awe for the fact of our concrete human existence. The concreteness of our physical, emotional, and spiritual life must be respected for the ways in which it is always already connected to the ethereal. This practice of research is a practice of rigorous interrogation of and accountability to this connectedness.

Jacqueline M. Martínez
Phoenix, Arizona

Acknowledgments

Special appreciation is due to the Fulbright program that funded me with a Senior Scholar position in Mexico during the 1988–1989 and 1998–1999 academic years. The experiences of those years enabled the deep autoethnographic fieldwork necessary to connect my personal experience with the greater cultural frames I was seeking to understand. Thanks also must go to the *Escuela Libre de Psicología, A.C.* in Chihuahua, Chihuahua, my academic home away from home for so many years. Dr. Rosario Valdés, Alfonso Chávez, Jesús Vaca, and the many students and staff members of the school who have assisted me and taught me greatly during the years I have spent with them. The University of Creation Spirituality, where I birthed the idea for this project, and the studies and experiences I had both as a student, and later as academic dean of the institution, cannot go unmentioned. Without a deeply embodied experience of the contradictions of spiritual liberation such as that afforded me through my relationship with UCS, I could not have come to have such an intimate understanding of my own entrapment as a spiritual woman.

The Hugh Downs School of Human Communication at Arizona State University deserves most special acknowledgment for its continued commitment and loyalty to me as a scholar, for supporting my most nontraditional work, and for providing a space where my ideas could continue to grow and develop. I owe special thanks to Jess Alberts, Judith Martin, Kristin Valentine, and the members of the intercultural communication and performance studies faculty. My Chicana and Chicano students at ASU provided, and continue to provide, the mirrors for my reflections to be examined from the heart. Their support and enthusiasm for my ideas have kept my project alive when I most needed the vitality only youth can bring.

To the women friends who supported me through the writing of this project: Special thanks to Mary Boardman, Connie Kaplan, Adriana Diaz, Susan Williams, Jann McGuire, Lynn Woltjer, Grace Hogan, Gloria Cuadraz, Jacqueline Martínez, Ayla Grafstein, and Sharda Miller. To the men of courage and of heart whose love supported me and encouraged me to take this work to greater audiences: Special thanks to Michael Ziegler, Chuck Burack, John J. Leaños, Myron Beasley, Rafael González, and Marco Albarrán. The women helped me birth it; the men have helped me learn how to take my work into the world boldly by their sides.

To my spiritual teachers, my yogis, my mentors: Russil Paul who taught me to feel the spirit in my voice and body, Richard Rosen and Kat Puralewski who helped me find the strength in the discipline of a trained body, Molefi Kete Asante who personifies dignity and ancestry, and Heather Valencia who keeps me connected to the earth and the dreamworld of my ancestors. To the courage of the members of the Aquarian Minyan in Berkeley, California, for daring to provide a model for expressed Judaism that helped me find the home where my cultural story could unfold.

To the committee who helped me with the first draft of this document: Anita Barrows, H. L. (Buddy) Goodall, Jr., Kristin Valentine, and Kylas (Pavani) Nagaarjuna, I am very grateful. There could not have been a better midwife for this project than Janet Soper, whose skilled artisanship and talent with formatting made a simple set of text files into a lovely book. My family deserves acknowledgment for having supported me without knowing what they were supporting and for loving me through my many shifts of shape. Moreover, I am eternally grateful to my best friend, Bruce Burger, whose faith in my voice continues to help María speak as Amira. *Baruch Hashem.*

Preface

It is exciting to release this work into the public sphere as an exemplar of an ethnographic piece of work with few, if any antecedents. Therefore, before you venture into the text, I would like to explain a bit of what my task was in producing this book. There were four primary goals I was attempting to accomplish, and I think that upon reading the text, the roads to each should become apparent.

First, I sought to create a method for what I find to be a dubiously enticing emerging form in the field of human communication—writing autoethnographic texts. Many of the scholars who have emerged as our ethnographers are those of us who started out as students of organizational communication. It was in the realization that one cannot fully understand the complexities of structure and power, of function and norm, ideology and culture, without immersing one's self into the organizational reality and writing its stories, that many of us found ourselves expanding our vision beyond the corporate horizon. Ethnography provided a nice model for our texts to take on a narrative style and more personal tone than our social science training had taught us. Yet, I found myself often in conversations with my colleagues and peers, wondering about the need for rigor, or standards, for a public method that explained the subjective turns on our journeys to write culture.

When the ethnographic began to become *auto*-ethnographic, these questions began to feel even more important. For how does one determine the basis for using one's own life story as the text for cultural critique? *María Speaks* is, on the surface, an autoethnographic analysis of the many ways that cultural socialization as a woman of Mexican ancestry involves the multiple narratives and imageries of a cultural history. It's about "me," the author, but if it's a successful auto*ethnography*, it's about many, many more persons—persons both male and female who have participated in producing our personas through the use of similar and parallel narratives of religion, power, race, and social status. I chose to invite myself to take the challenge to create an embodied, subjective methodology that would unearth, or *interrogate*, these cultural patterns through a performative text, whose analysis is between the lines, becoming louder and louder with repetition, like culture. The more you stay with it, the more it begins to speak to you.

It became apparent to me as I worked on the project, that the form and structure for my text should come from the culture I was discovering as I looked at the interactions and intersections my own life shared with the systems of meaning I found. The use of the *rosary,* as an intentional journeying heuristic of Roman

Catholic spiritual practice, became my stimulus for seeking new journeys to help the silenced *María* speak. For she was not only I, in my former persona as María Cristina González, but also *María* was the silent woman journeying along every step I found myself taking. Being a social and cultural creation, I used the text of my own cultural self to reveal what she was saying by speaking to the very archetypes and personas that lived within my cultural psyche. Revealing what I felt I *could* and *should* say to these figures told me what I had made real—the stories from my own life that paralleled the narratives I had learned became clear. This methodology of *art as meditation* casts light on the cultural themes so they could be the focus of the story, rather than the author's persona.

Second, I wanted to produce a piece of work that could be read by scholars and nonscholars alike. I wanted my ethnographic tales to speak to women who would not be presenting their lives at an academic conference, but who would be participating in producing and reproducing the very themes my work was revealing and sharing. So, you will find in this book a detailed description of the ways in which I worked to share this work through staged performance of *María Speaks.* I include poetry and personal narratives without explicit academic analysis, because I wish the text to be accepted as ethnographic. I did not want the text to have to argue for its ethnographic nature. I hope to share this book with the public through continued performances and dialogues that invite María to keep speaking.

My third motive for writing this book was to provide something that young scholars who are learning to write autoethnographic texts can use as a guide for establishing the rigor and methodology for their own cultural texts. I want to encourage scholars to be accountable publicly for the choices they make when using their own lives as the text of cultural writing. I want to establish a precedent that demonstrates the parallel and intentional cultural immersion work that I believe must go on while looking at one's own life to write an *autoethnography*. This is not simple autobiography nor the sharing of unedited personal journals for cathartic relief. I am a scholar in the field of human communication, dedicated to the understanding of intercultural communication. When I use my life as a text, I want to help others see the complexities of the layers and patterns that interact and bounce off each other simultaneously, and in competition, to create "a person." There is no one explanation for how we communicate within a culture, and only rich ethnography can juxtapose those multiple explanations in a nonlinear narrative fashion most like the lived ways in which we have learned our systems of meaning (our cultures). I wish to encourage young scholars to avoid simplistic understanding of culture and to realize that if they are overwhelmed upon reading my book, that this is precisely how cultural immersion in a new world should feel. When it feels clean and tidy and easy to get with one sweet reading, beware!

Finally, I wanted to honor my ancestors of all my mixed-heritaged traditions by presenting an honest representation of my struggles, without rejecting their eternal role in creating who I am. This is the same as it is with our world today and always has been. We have to look at our past to see who we are. We have to understand how we have come to be who we are and to realize that there is no human alive without a complex voice rooted in rich ancestry. Learn who our ancestors are, learn to speak to their images to better understand our place today, and ask others to tell you about theirs. Then, in fact, María does become the Great Mother, birthing a world of humans who can see their shared *hermanidad*—we are sisters and brothers. That is the ultimate reason for communication. I hope María speaks to you as she did to me.

Sarah Amira De la Garza
Phoenix, Arizona
2003/5763

Part I

The Journeys Before the Journeys

1

The Preparation

Mystery is like a seductive voice ... singing to you, directly to you, only to you, breaking you away from what you thought you were, which until that very moment you thought was the whole and substance of your life. Mystery(is) ... a dance that promises something you will always remember or, maybe, that you will never forget.

—*H.L. Goodall, Jr. (1991)*

Having never given birth to a child, I have worked to understand the question of what it is to be a mother. I have explored what it is to have the energy of a mother within me, what an archetypal form of mothering might be that transcends culture and physiology. I have worked throughout my life in many capacities with children and adults, in programs for the prevention of child abuse, in recovery programs for adults who survived such abuse, and in a variety of youth programs. I know from these experiences that biological birthing itself does not make for good mothering. There is a sort of engagement with life that embodies the energy of "mothering" that is essential to thriving and, although it is typically associated with the female act of birthing a child, it is much more archetypal and less biological.

I never gave birth to a child, but my work as a teacher and role as an aunt and mentor to young people, my positions of leadership, and even my role as lover to the man I love—all these have required that I know how to mother. Born into the patriarchal religion of Roman Catholicism, the patriarchal cultures of Texas and Mexico, and pursuing a career as a university professor—where the majority of leadership roles continue to be held by men—I learned that leadership and power

came from a patriarchal way of acting. The taken-for-granted models for power and human agency are based on masculinist engagement with experience. In this system of interaction, women, by their accommodation, become sycophantic and flirtatious at best, frightened and menial at worst. Responses to disappointment are bellicose, authority definite and rigid. A solution often suggested—a matriarchy—would in my mind's projections create a similar dynamic of unbalanced power. Instead of trying to please the authoritarian "pater," or father, we would turn to attempts to please the dominating mother. Domination is domination.

Whenever I sought power in my life, the hierarchical system which only had room for a patriarch or a reactive matriarch, led me to an unconscious knowing of Mother as someone I did not respect, but rather feared or resented. She was the mate of the evil Father, either acquiescing to his domination, or rejecting him with unbalanced ferocity. As a woman, I came to a place of not knowing what my performances in life meant—were they authentic presentations of my agency, or intricately scripted roles? In order to understand this, I sought to understand who "Mother" is within the patriarchal world within which I shaped my personas.

> I can feel you here with me again
> O Lady
> and I sense your silent glee
> when my mind's discourse
> heeds your direction
> You are the mate of he who would abuse me
> you came silently beside him
> and entered my soul and mind
> while his body and breath
> took mine
> it is You, Lady, who lingered
> it is You, who have remained in my life.
> He in all his many forms
> so easily recognizable
> but You, Lady, take *my* form
> and hide
> You, the lover of death
> who will not allow me to live.
>
> It is a sad little irony that we focus
> so seriously on the *man*hunt
> seeking his footsteps and fingerprints
> identifying his acts and words

until we find his face before us
inviting projections
teaching us to voice
a well-rehearsed persona of power
while all the while
You, Lady, lie comfortably
in the waiting room of my soul
practicing the whispers
to sound like my voice
You hold me captive
every time I approach freedom.

What a wonderful pair you make
it is amazing we have not seen you
have not realized
that behind every great man
there is a woman
and behind every great act of
patriarchy
there is matriarchy
while he dominated my body
with force and thrust
You dominated my soul by
making me forever a frightened
child
wanting mommy
and fearing forever to go anywhere
alone.

 I knew in my heart that I needed a different relationship with the Mother. I needed to know her differently. I did not want a Mother who would never let her children mature and grow, anymore than I had wanted a Father who would never allow for my own will to be expressed or enacted. These metaphoric ways of looking at Mother and Father, the matriarchal and patriarchal views, are stubbornly insistent on domination and denial of human nature. I sought a view of Mother that would allow the full cycles of life and death to exist. Without Her, I knew that I could never know a Father well either. I began to consider matriarchy as the parallel and competitive dominating force to patriarchy, as part of my preparatory reflection for an ethnographic study of my own life as the cultural text where stories of the Mother were written and told. At some level I knew that these generative

and structuring archetypes were linked to the most creative aspect of our being: expression.

Patriarchal dysfunction occurs when the protector role is taken to extremes and individual will and power is negated. The dysfunction of matriarchy is seen whenever a human creator will not allow the midwives to sever the umbilical cord to their creation. Together, they guarantee a damaged creation and a fearful climate. One brings about enforced silencing through authority; the other is a fearful, insecure unwillingness to express. They are in many ways in symbiotic relationship within us. Much of what I had learned about leadership, love, and authority in my life had been warped by an inherently patriarchal and reactively matriarchal view of power and strength. A dysfunctional matriarch will call forth the dysfunctional overpowering patriarch and vice versa. The constant struggles and efforts to deal with the hierarchical oppression of the systems for religion, family, education, and love in my life were wearing me thin and making me ill by the time I reached my late 30s. In order to find something new and to bring wholeness to my life and those around me, the fierce dependencies that patriarchal and matriarchal ways of relating create would have to be replaced.

It is hard to face the reality that being a mother, that being a woman, requires harsh letting go of intimacies and bonds which have been meaningful and symbolic. Being a mother means opening to the pain of expelling that which we have nurtured intimately. Being a mother means having the strength and courage to cut the umbilical cord. To be a mother is to acknowledge that every act of encouraging the growth of another human being we have loved is an act of surrendering the dependence on their energy. As mothers, we invite the cries of the child, angry that he must no longer suck from the breast. As mothers, we tolerate the bumps and scrapes of the child learning to walk. As mothers, we invite the solitary sadness of having let our loves go. This is an archetypal pattern in all of our lives. To express as a mother would be a truly courageous and giving expression, devoid of identification with martyrdom or propriety.

There is the time when we come to realize that, in fact, if we clutch at the recognizable form, we are not allowing love to be. It is a false union to grasp and clutch, to stay after the birth has occurred. If we clutch to God or Mother or Self as immutable constants, we invite suffering that defeats a transcendent unity. The ultimate union and Oneness is one of complete surrender. The energy of the Mother is that incredible love that is willing to do anything, no matter how radical or extreme, to return creation to the One. It is a freefall. It is terror and divine openness. It is Tonantzin. It is Coatlicue and Tlacolteutl. It is Shekinah and Leila. It is Kali and Shakti, Ishtar and Isis. She comes in many forms and measures. And in my life, she has most prominently been present as María, the silent image of Mary. I've

been looking at her face, listening for her voice all of my life. Through this autoethnographic project, I found her face in mine. Now, she speaks.

Methodology

In order to speak, the thought of the mind must "bend over" and contract its own brilliance for the sake of communication to others.
—*Ginsburgh (1991)*

As human beings, we come to our questions and inquiry girded with the assumption that all we have acquired in our lives, from our families, schooling, relationships and life experiences, has prepared us to know. The relationship between ourselves and what we know, our *epistemology,* is a fabric woven from past experiences of knowing. When we begin to ask questions new to us, we can enter into what I have called the "spring" of our inquiry (González, 2000). It is the essence of the spring of our inquiry to invite a deep emptiness and purification, a deconstruction of our knowing. Instead of approaching new questions blindly, allowing our pasts to determine unconsciously how we will answer them, this preparatory phase of inquiry allows for our epistemology to emerge from a deconstruction of our knowing. Our epistemology, the way in which we know, can evolve through a conscious reconstruction of our experiential base, inviting deeper wisdoms available through willing embodied engagement with the very things, the very phenomena, we are seeking to understand.

An epistemology, thus framed, becomes a reflection of our relationship with the object of our attention. By dropping our engrained expectations through disciplined practices of inquiry, the mysteries of our questions can begin to speak to us. The relationship between the knower and the known is then an intimate and subjective creative process. We learn to see through a process of surrendering to mystery. Discovery is not so much uncovering an objective external reality, in a clinical sense, but the growing awareness of our intimate involvement with our subject. We are part of what we observe; we shape it, just as it shapes us. From such a perspective, our previous knowledge serves not as the structure of our inquiry, but as alternative wisdoms which can be integrated with that which we will meet in what we study. We begin, in the spring of our inquiry, to remove our clothes and stand naked before the experience that will show us how to dress.

This is the perspective that I brought with me to this project. A perspective that is a nonperspective. It is a paradoxical ontology I have called "the four seasons" due to the fact that although we can anticipate the arrival of predictable forms of experience (knowledge), nature has its own wisdom regarding how and when it will arrive. Further, it is our interaction, or engagement, with the arrival of

the seasons that serves to create our specific epistemology or perspective. In this particular study, I sought to go beyond a simple use of the basic subjective methods of reflective writing as a way to write autoethnography. In keeping with a tradition committed to studying culture through its *writing,* my efforts were to develop a model for a systematic use of cultural themes as the basis for autoethnographic, or self-reflective, cultural writing. These themes would arise, I held, from a rigorous surrender to ethnography as a spiritual practice (González, 2003), where the levels of symbolic and cultural knowledge are accessible through an acknowledgment of the ineffable as inherently a source of what we can know.

Emergence of the Study's Guiding Themes

As I set about exploring an alternative set of tools that might be more appropriate for rendering an *autoethnography,* it first became important to me to articulate what I considered this controversial form of cultural text to be. Ethnography, in its most simple etymological translation, is the *writing of culture.* Through extension, an *auto*ethnography would be, in a sense, the writing of the culture of *self.* The informal critiques—that I have heard regarding those who have chosen to take on the mantle of autoethnography—have included many references to its tendency to appear as narcissistic self-absorption or to reflect little evidence of analytic method in the authors' development of the presumedly cultural text. In order to avoid the seemingly easy trap of simply "telling my story" and mounting my personal soapbox, I determined that perhaps it was wiser to begin with the *ethnography,* rather than the *auto* in the research process. Once I became clear on the cultural themes that were of interest related to issues of womanhood and Mother (since these were the issues that motivated my study), I would then use those themes to shape a systematic, reflective method for using my life as the cultural text of primary interest to the *auto*ethnography. My resulting research text would then be an example of what I have defined as the autoethnographic text: the *intentional storytelling of culture through the lenses of one's own life.*

The methods I used for this work began, therefore, somewhat traditionally with an emphasis on observing, interviewing, and studying. In 1989, after a year as a Fulbright scholar in Ciudad Chihuahua, Chihuahua, Mexico, my informal fieldwork had yielded insight into the use of specific labels repeatedly used for referring to women. With the help of a group of young college women from the *Escuela Libre de Psicología, A.C.,* I conducted observations, informal interviews, and brief surveys. Seven terms seemed to enjoy a high level of shared cultural meaning as labels for women.

In 1998, I was fortunate to return to Chihuahua on another Fulbright grant, and I decided I would return to my previous area of interest. By this time, I had

also begun my work studying notions of Mother and held an openness to the possible connections between these areas of work. I spent approximately three months journaling and observing, formally interviewing a few women about the labels I'd previously identified, and paying close attention to my own experience as a woman in Mexico—who could herself be identified by several of the terms. These labels, from my unpublished study, (briefly) were as follows:

- *La Señora*—the woman of adult stature, with a proper married role in life, meriting respect on the basis of her marriage and motherhood. She has had a proper religious wedding, besides the legally required civil ceremony.
- *La Señorita*—the young woman, whose behaviors and appearance are based on the ultimate attainment of the role of *Señora*—to get a husband and a home and to have children. Other accomplishments are peripheral to this central goal.
- *La India*—the indigenous woman of native "Indian" ancestry, often living an earth-based life and still practicing indigenous traditions in clothing, spirituality, marriage, and language. She is most frequently of the lowest levels of socioeconomic status and is the only label that can be identified solely through racial categorization.
- *La Santa*—the woman who is highly Catholic and who makes her life's decisions based on an incorporation of Church standards of morality and behavior (if a nun and church-affiliated, she is then *La Religiosa*).
- *La Liberal*—the woman who through exposure to "other" ideas, often through education or travel, does things that break the rules—most often referring to sexual mores and conduct, marriage, and religious practice (or lack thereof). It is easier to attain this label if one is of upper-middle class or higher socioeconomic status. A variation of this label would be *La Profesional,* the working woman with a higher class profession, as opposed to working-class women.
- *La Corriente*—a woman reflecting lower socioeconomic status who exhibits liberal sexual mores and conduct, often reflected through language use, dress, and makeup.
- *La Extranjera*—the woman from another country, whose failure to follow the rules is excused, explained, or expected by virtue of her foreignness.

La Virgen de Guadalupe
INDIA <=> Extranjera
estoíca Atención Mercadotecnia
Religiosa de los españoles
Santa

La Malinche "al indio lo
India /violada
|
revertió su papel
mujerzuela situación
corriente propia
llegó a manipular con su cuerpo

La llorona
IMAGEN del Dolor:
de la mujer que pierde
a sus hijos. Da miedo
ser así.

Sor Juana Inés de la Cruz
Religiosa
Señora = de respeto
Liberal:
"se atrevió a decirles la verdad
a los hombres"

Notecards from Interviews

5/7/98

I've been wanting to write in here for quite a few days. Since talking w/ Alfonso Chávez in Chihuahua about my upcoming move to Mexico. I asked him about aquiring me an e-mail address, & then about wanting a place to live near the school. He started to ask me what kind of place I wanted — if I wanted to live with a family or alone. I told him I didn't want to be "taken care of," which I meant as saying I want to come + go + do as I pretty much please. He said they were in no way not going to take care of me. Waves of culture shock shot through me as I felt my volition being stripped from me. It was the best I could do to add in as semi-jest, that I did not want a family that was too Catholic. He laughed. I meant that I didn't want to have to go to church + be mournful. I hope he didn't think I meant I was a rampant sexual sinner.

This all makes me think of the validity of the study I began when I was in Chihuahua last time — about the eight categories of women + their placement on dimensions of social class, sexual morality + religiosity. This conversation w/ Alfonso was a good intro. Maybe tradition/ modernity?

May 7, 1998 Field Journal

La india

La extranjera

La señora

La señorita

La liberal

La corriente

La santita

So I conduct the study by having groups come up with as many words for women as possible & then begin to have individuals cluster them. Next step would be to have them define the communicative behaviors of each cluster of significance.

Need to get some books on ethnomethodology

Use this methodology w/ the students for the alcoholism study.

How about the neurotics anonymous study?

Second Page from May 7, 1998 Field Journal

These were the original seven labels emerging in my 1988–1989 work, with notes on supplementary labels based on 1998 discussions and interviews I had. Some suggested that another should be added—*La Soltera,* or the single woman who does not marry, but is not in a religious order. It is a variation on *Señorita* and can become a derogatory term if used as *solterona* (a disparaging term to reflect something analogous to an "old maid").

As I reflected on the labels, I could see the interaction of four primary dimensions in the labeling of women: religion, sexual mores, social class, and race. Each of these dimensions operates with the culturally defining power to label a woman based on her ability to portray the feminine ideal. This feminine ideal was most often characterized in my conversations with women in Chihuahua through the Christian role of Mary, the wife of Joseph and the mother of Jesus. This preliminary work provided the thematic inspiration and backdrop for the project that would emerge while I lived in Chihuahua during 1998–1999.

Because of my own Mexican ancestry, I hold a tacit understanding of the mores of being a woman in Mexico. I was raised during the formative childhood years with the heavy influence and constant and intimate presence of my two grandmothers—both Mexican immigrants who never spoke a word of English to me. My years of travel to Mexico throughout my adolescent years and into early adulthood allowed me to learn the implicit norms of social behavior for a woman in Mexico, while my life as a Mexican American, *Chicana,* in Texas and other parts of the United States, provided an alternative perspective—that of the woman who still carries the archetypal imagery of the mother culture, but who is attempting to live with a postmodern identity. This juxtaposed cultural identification was the source of a deep emotional response to the work I was doing and created in me a desire to better understand why I was so interested in it.

The autoethnographic nature of my work was emerging, and the basic traditional methods I had learned and supported for most ethnography was limiting to me. I desired a discipline and rigor for my work but felt it was time to take creative leaps and risks. The early work of Barney Glaser, exploring the idea of theoretical sensitivity (1978) and his earlier work with Anselm Strauss (1967) had introduced me to the idea that ethnographers had a responsibility to integrate their experiential and academic knowledge in the analysis of their data. What I found facing me, in the autoethnographic challenge, was the absence of specific systematic forms of practice that would allow the exploration of my own life to reflect my desire to do so in a conscious and publicly rigorous fashion. I wanted to incorporate tacit knowledge and conceptual sensitivity throughout the process of my inquiry in a mindful practice, rather than an impulsive use of potentially egoistic—albeit subjective—personal preference (which could likely result in something interesting, but which would not systematically carry the explicit awareness of the cultural

aspects of the story—how my life reflected the bigger cultural story). What evolved was a methodology that would not only be subjective but also embody the intuitive and transcendent, calling upon the use of an active spiritual practice as the basis for the insights. While working on these aspects of the method, I wrote to my mentor of over 20 years, Robert Hopper, in the last months of his life. I am forever indebted to those conversations as having provided me the courage to see that my practice of ethnography was itself a spiritual practice (González, 2003). As such, great transformation and healing would be possible through my conscious proclamation of being willing to see whatever I would find before me.[1] The methods I developed for an autoethnographic study of my life, as the source of cultural insight, were an acceptance of this invitation.

Art as Meditation as Method for Autoethnography

Traditional methodologies for cultural critique have contributed to the perception that we are examining something separate from ourselves when we critique culture. By focusing on the study of an external subject/object, it can appear that we are in some way objective and separate from that which we study. I believe that even when we explore our own stories, if we do so with unreflective lenses (with no intent to interrogate our assumptions or standpoint), we are still separate from our subject—ourselves. Although distanced perspective may be desirable in certain forms of research and rhetoric, it would be problematic for my work as it was unfolding.

As my work progressed, my initial interest in the labeling of women grew broader, to the general ways in which women's actions and words were systematically constrained. I recognized a pattern emerging, in which the role of mother and maternal behavior patterns were central to being a woman (in a paradoxically constraining way). Somehow, the social mothering behavior itself is seen as the reward (being like Mary) for the sacrifices of freedom in many forms that women are expected to make. I encountered one woman during my early fieldwork in 1998, to whom I found myself referring in my notes as acting "as if she believed she was the Great Mother." Her seemingly willing identification with a scapegoated Motherhood allowed her to use motherly intentions to be excused from accountability in social situations.

This flippant use of the term "Great Mother" in my field journals reminded me of the history of Mexico, and the many images of the Great Mother in the indigenous history of the pre-Catholic, pre-Hispanic cultures. In particular, I was reminded of the image of Our Lady of Guadalupe, whose temple is built on the mount Tepeyacac (see Mini, 2000) the traditional site of worship for Tonantzin, the earth mother. Tonantzin's name can translate in a beautifully intimate and

endearing way as "mommy," or "my little most precious mother." What had happened to her? Had she been subjugated into a distorted modern version of woman?

I read voraciously the work of Jeremy Taylor (1998) on the "repression of the Great Mother archetype," as well as that of others on similar topics. I also visited with indigenous dancers in Mexico City who shared with me that the "truth" was not known about Tonantzin and Guadalupe. I took art lessons from a Mexican painter who, as Mexican artists tend to be, was also a great lover of philosophy and history. He shared with me copies of rare books that informed me of aspects of the story of Guadalupe I had not known (Benítez, 1991; Ortega, 1985; Barabas, 1987). Some of these aspects are included later in this work.

I began to wonder how the experience of the indigenous Great Mother might have been repressed in Mexico, and how this affected the roles and behaviors of and around women. I began to wonder how my own life, as a woman of Mexican ancestry, might also reflect this repression. If it did, or does, then might that not be true of people of Mexican ancestry in general? Would it be possible to work to enable this awareness? Could a consciously reflective autoethnographic process provide me with subjective insights? My questions evolved as follows.

Given the reverence of the Great Mother held by the pre-Catholic Mexica/Aztec peoples of what is now known as Mexico, how might She have been repressed and hidden? How might images of Mary, as the virgin mother of Jesus, hold answers to the relationship of people of Mexican ancestry to the Great Mother? Would renderings of the stories of traditional female historical and cultural figures in Mexico also function to repress the essence of the Great Mother? And if so, how? And finally, how does my experience of my identity as a woman of Mexican ancestry allow me to answer these three questions? Could I engage myself deeply and subjectively for insights that might prove uncomfortable but that would, perhaps, provide more than explanation? Could I find a way to give women like me a chance to find our own voices as women? Could my own experience in such an autoethnographic venture speak to others?

To address these questions, I would look to myself as a cultural site where the answers would lie. I began to look for evidence of the repressed Mother in the lives of women of Mexican ancestry, beginning with my own. I reflected on experiences throughout my life and while visiting and studying Mexico. I opened myself to the possibility of a methodology that could access this knowledge.

During the first phase of my fieldwork, I was looking for insights into my own reactions and attitudes as evidence of my implicit, tacit, cultural understandings. This phase corresponds to the "spring" of ethnography, where the soil is being tilled, fertilized, and prepared for seeding (González, 2000). I read many books, in both Spanish and English, and used them as the focus for contemplative meditation, especially over the first six months of my time in Mexico. I paid attention to

those things that triggered intense emotional responses in me, both positive and negative. During this phase, I also dedicated myself to preparing my body, the site of the human instrument I am in my work.[2] I held regular sessions with an acupuncturist over a three-month period, sat in silent contemplation several times a week at the great cathedral in downtown Chihuahua, and I wrote in my journal daily. I also refrained from using taxis and buses as often as possible, preferring to walk and feel my feet in connection with the earth again and again. I ate freely and listened to music, went to museums, and watched the national favorite *telenovela,* *"El privilegio de amor"* (The privilege of love) with new friends. I struggled to include a regular practice of yoga, meditation, and chanting as well. I was attempting to sensitize not only my mind but also my body to my habituated cultural responses to experience.

In the traditional "summer" of ethnography, the explicitly ethnographic activities of observation and note-taking begin. In this project, my move from spring to fall involved my continued immersion in Mexico as a Fulbright scholar, utilizing my time to observe and participate in as many relevant activities while there for the 1998–1999 academic year. Field journals were kept and informal interviews conducted with both men and women. I attended religious and spiritual ceremonies, meetings, and gatherings in homes, churches, and native indigenous communities. During this time, I conducted several interviews with women of various ages and social class groups, wishing to inquire about the feminine archetypes operating for them. It was a way to "member check" (Lincoln & Guba, 1985) my own conclusions and the interpretations I was making. Their answers helped me to identify the feminine figures in Mexican culture and history who seemed predominant in the narratives familiar to the women of Mexico.

The "fall" or "autumn" of ethnography, in this particular study, departs from the traditional inductive analysis of data based on rigorous coding and categorization of fieldnotes at this stage. I have a deep respect and fondness for these methods, but in this study I found the cognitive distance that such activities would create to be an obstacle to the insights that seemed so deeply embedded in my unconscious awareness. Other methods for recognizing the nature of my "findings" were needed. It was at this point that "art as meditation" was implemented as the spiritual practice for intuitive induction of insight. Based on the themes that had been arising in my personal journals and informal interviews and observations during the first five months of my stay in Mexico, I selected five female historical/cultural figures who play prominent roles in the cultural narratives of women of Mexican ancestry.[3] These women became the vessels for the cultural themes upon which I would base my autoethnographic examination of my own life. They are women whose stories were constantly referenced in my conversations and interviews. Their imagery abounded. They are:

- *La Llorona,* the mythical weeping woman who travels the night and darkness, like the wind, seeking the souls of the children she has killed.
- *Sor Juana Inés de la Cruz,* the 17th-century nun whose image appears on Mexican currency and is celebrated for her feminism and literary outspokenness.
- *La Malinche,* or *Malinalli,* the indigenous woman who was given to Cortés, the Spanish conqueror, and whose exemplary linguistic abilities aided him in converting the native peoples to the Spanish Catholic ways presented to them.
- *Frida Kahlo,* the German-Mexican surrealist artist of Oaxacan-Jewish ancestry known for her boundary-breaking lifestyle and art reflecting the agonies of a life lived in severe physical pain (the result of a serious accident in her youth).
- *Tonantzin,* the previously mentioned earth mother goddess form of the Mexica peoples.

Because of the strong Roman Catholic influence in creating Mexican national culture as it exists today, the images of Mary, the mother of Jesus, were also prominent. The women I interviewed referred to the nature of *la virgen* in her various manifestations as evidence of feminine personas. I selected five of these manifestations of Mary who figured frequently in the Mexican narratives. These historical personas were selected for their thematic correspondence to the five women:

- *Nuestra Señora del Sagrado Corazon*—Our Lady of the Sacred Heart, whose image bears a perpetually wounded heart and serene sorrow, among other attributes.
- *La Milagrosa*—The image on the Miraculous Medal, an image that offers miracles to all who dare to wear the medal of the woman in blue, with light streaming from both of her hands.
- *Nuestra Señora de La Luz*—Our Lady of the Light, one of the several images (including *Nuestra Señora de los Remedios*—Our Lady of Remedies—and *María Auxiliadora*—Mary the Rescuer) of the Blessed Virgin carted around by the Spaniards as they went from place to place on the conquest. She wore a crown in the majority of instances.
- *La Dolorosa*—Our Lady of Sorrows … shown with the face of a grieving Mary as she looked upon the cross at her crucified son. Often shown with stones, nails, a wreath of thorns, the artifacts of Jesus' persecution.
- *Nuestra Señora de Guadalupe*—Our Lady of Guadalupe, the image of Mary purported to have appeared to a Nahuatl-speaking Aztec man by the converted name of Juan Diego (beatified by the Vatican as a saint,

although there is no historical evidence that he existed). She is referred to as the "Empress of the Americas."

I will engage these images later in the text, sharing sample visual images enlarged from popular holy cards as well as poetry and prayers used to deconstruct their meaningful role in my cultural sense of who I am as a woman.

The number five (five themes, five women, five manifestations of Mary) was chosen due to its intuitive correspondence to the five mysteries in the rosary—the traditional, and predominantly feminine, practice of prayer to Mary in Mexican churches throughout the country. The practice of praying the rosary is a "quiet" form of prayer, one that is routinely suggested in Mexican cultural contexts when someone is troubled. It is selected here because of the potentially silencing role that the phrase, "why don't you pray the rosary" can have as a response to women with valid social woes that beg expression. The traditional rosary reflects the five mysteries of the life of Mary. I chose to organize the methodology around five journeys, with an intentional embodied emphasis on the nature of the reflection conducted through art as meditation.

In this work, I would begin to find my life laid bare. I sought to study myself as a way to understand my life, my culture, and the ways in which I am inextricably a cultural human being when I interact in the world. My starting assumption was that the meanings I had inherited and absorbed through my lifetime of enculturation as a woman of Mexican ancestry held keys to what I could and could not become.

May. 10 11:06 pm	Just saw "Amor Prohibido" - I hope I can get the English title for it. About a Venetian courtesan during the Spanish Inquisition — Veronica Franco. About women + power + expression + our minds.
the message	I ~~realized~~ became aware of something. I can cry when I make mistakes - later. I can choose how I will be. ⌐G-T
Guadalupe- Tonantzin	A major awareness. I can choose. I can be different + be part of life. — Frida I can select the options from which I choose. → Sor Juana
Malinalli←	I do not have to be a slave to society. So my question to myself is - how do I want to be?
	I want to be quiet + calm, saying only what I really want to say. I want to do what I do without trying to "sell" its value. I want to wear my clothes until they wear out. I want to cook. I want to be my own woman.

Page 62 from Field Journal

I hold that culture and all forms of social organization are inherently coarising; therefore, there is no way that an examination of my life can avoid being simultaneously an examination of the world that cocreates the woman that I am and have been. A critique of my culture is not a critique of an agent external to my *self,* but an immediate critique of my own personas—the roles I play and the voices I express and repress as part of that culture. The enemy forces, the structures and voices that have oppressed me are *part of me,* equally as much as the impetus for empowerment and liberation. My method of inquiry had to be able to maintain this dialectic.

I believe that our worlds are socially cocreated and that, therefore, a knowledge of one's self is inherently a knowledge of one's social world, and vice versa.

On the basis of these assumptions, I was stating that in my own life, as a woman of Mexican ancestry, the Mother was repressed. This meant that a study of the repression of the Great Mother in the experiences of women of Mexican ancestry could be done through an examination of my own life. I wanted to avoid the temptation to separate myself artificially from that which I was studying, so I sought to develop—in my methodology for cultural inquiry—methods that would honor the self as a living, breathing site of cultural knowledge that expresses itself. Because this knowledge expresses itself, I sought methods that would focus on forms of expression intentionally, mindfully, and openly. The methods that emerged were an application of "art as meditation" as a route to specific cultural insights.

During the last two decades of the 20th century, theologian, writer, and educator, Matthew Fox introduced a structure for education that balances traditional conceptual/rational/text-based learning with experiential/intuitive/meditation-based learning. This latter form of class or learning experience he calls, "art as meditation" (Fox, 1995).

In art as meditation, the practitioner engages in the doing of a form of art as a meditative path that highlights one's connections to the divine, celebrating the four paths of a creation-centered view of existence (Fox, 1980). The connections become apparent in a multitude of ways, with each art form offering its own particular routes of connection. Sculpture, painting, singing, and dancing all open the practitioner to embodied forms of knowing. Writing poetry, prayers, letters, and an autobiography utilizes written text as a dialectical source of insight through expression.

As a student in the Doctor of Ministry program Fox founded at the University of Creation Spirituality, I had taken many of these classes over a three-year period. Although they were deeply moving and healing experiences, they did not ever really show me how to engage the insights available through them in a systematic study of my own life. That was left to my own resources. My experience with Fox's concept of "reinvention of work" (1994) also had left me motivated, but without any sense of the praxis of such a philosophy. So I returned to the ideas I had begun having in the early 1990s, when I used poetry to record my field experiences studying shared practices of Native American spirituality (González, 1998). I suggested this sort of practice to myself as an integral part of the methodology of ethnography as spiritual practice, in which a "methodology of surrender" (Goodall, 1991; González, 2003) allows intuitive, mystical insight to provide knowledge about cultural meaning. I borrow the term "art as meditation" for the implication that artistic, impressionistic (Van Maanen, 1988) and reflective writing can be used with systematic and rigorous intention to open a meditative place of awareness of the nature of one's experiences. Further, this insight can reveal the cultural sources

of interpretive frames we as human beings use to determine who we are, what we can do, and how and what we express.

So much of what we call nature is really the (TFG). When we do ethnography we are inviting an awareness of the construct-ed reality. Once this has occurred, we are faced with the potential to see 'nature' as it really is, without boundaries. Ethnog-raphy so conceived is inherently liber-atory. It doesn't make things more comfortable. It makes them more visible. Our social acts are not natural. Sometimes we don't want to know this.

taken for granted

Page 09 from Field Journal

Art as Meditation Methods

My project utilizes this application of art as meditation as the spiritual method-ological practice for the study of culture. Specifically, it does so in an autoethnographic study, in which the emphases in artistic practice are autobio-graphical and self-expressive cultural forms in written texts.

The art-as-meditation practices I chose were organized around five thematic journeys, with an image of Mary and a cultural/historical feminine figure selected to correspond to each. Specifically, I chose the following five journeys to exemplify the five themes, each used to guide the exploration of my own cultural life. Each journey would use the archetypal symbolism, imagery, and stories of the corre-sponding women and manifestations of Mary.

1. The Journey of the Heart, or of unexpressed sorrow and wounds (*La Llorona* and *Our Lady of the Sacred Heart*)
2. The Journey of the Mind, or of the formal boundaries constructed through institutions and thought (*Sor Juana Inés de la Cruz* and *La Milagrosa*)
3. The Journey of the Word, or of the creative and social power of language and speech (*Malinalli*, or *La Malinche* and *Nuestra Señora de los Españoles—various images*)
4. The Journey of the Body, or of deeply embodied injuries and wounds (*Frida Kahlo* and *La Dolorosa*)

5. The Journey of the Shapeshifting Woman, or of de/reconstruction of identities and lived social forms (*Tonantzin* and *Our Lady of Guadalupe*)

I developed the following art-as-meditation methods to access the subjective cultural knowledge available in my own life:

Personal Letters. I wanted to de/reconstruct each of the historical/cultural female characters for insights into my *self* as a cultural woman. I did not want to engage a textbook persona, but the woman each figure was/is to me subjectively. I wrote an actual personal letter to each, attempting to engage her as I knew her. This would require examining and studying each life/story and writing the letter to express the issues, concerns, and questions that a reflection and comparison to my own life allowed to surface. In particular, I sought to reflect on traditional ways in which each woman had been portrayed to me and that had, thereby, obfuscated alternative ways of viewing the same story. I was seeking ways in which "repression" might have taken place, repression of aspects of being a woman, which could link her (and consequently, me) to the archetypal Great Mother.

Autobiographical Narratives. Upon writing the letters, I then selected themes which surfaced from my own life experience. By writing an autobiographical narrative of incidents in my own life, which paralleled the uncovered issues in the lives/stories of the five women, I hoped to discover the nature of the cultural context(s) for the issues in my life.

Poem/Prayers to the Virgin Mary. Having identified the themes in the letters and autobiographical narratives, I then turned to address the selected images of Mary. Since the tradition in Roman Catholic practice is to have specific prayers said to these images of Mary, I chose to write new prayers to them, reflecting my growing (re)understanding of their significance. However, in order to demonstrate the de/reconstructive function of the process this methodology was allowing to emerge, I chose to first write a poem to each image of Mary. These poems highlighted my growing awareness of the delicate nature of de/reconstruction of the sacred, as well as what my new understanding of the Mother was revealing to me. The prayers were then addressed to the Great Mother within the image of Mary, addressed to Her as she was coming to be understood. In many ways, these were new understandings of my own culturally embodied self.

Spontaneous Poetry. In the process of working through these journeys over a five year period, I found that writing spontaneous poetry would often capture the essence of what I was experiencing. Sometimes I found that poems I had written

years earlier now spoke more loudly and with more significance. I have included some of these poems from my journals here as well.

Performance. One of the outcomes of the discipline of daily practices to support my reflection was that I began to discover my body. Mexico had always threatened me in part because of the outward sexuality of women when they dress up. This was the truth even in my hometown experience of going to the "Spanish dances" while I was in high school. As I confronted the women of my cultural history through my creative writing, I began to recall the times in my life that highlighted the same themes that these icons of Mexican femininity were stressing in my interpretation and memory of my own experience. I invented meditations in response to Frida Kahlo, *La Llorona*, Sor Juana Inés de la Cruz, La Malinche, and Tonantzin. As I continued with my reverie of playful spiritual practices, I realized that my body was dying to express itself as the body of a woman. I had kept it too long hidden out of fear, propriety, and a dysfunctional identity as a young girl who had blamed herself for her sexual abuse. Suddenly nothing was true anymore, so I wanted to release myself from the bondage that continued to make me vulnerable to sexual violation throughout my adulthood. The paradoxical turn was that I began to celebrate my sexuality, taking off the layers of camouflaging clothing I'd worn out of habit through the years. I began to enjoy the appearance of the feminine curves of my body under well-fitting clothes, and to appreciate the fact that I did not have to hide them.

In so doing, I suddenly wanted to explore my insights into the themes I was exploring with a full engagement of my body. I soon realized that this is where the spiritual traditions I'd inherited from my upbringing did not allow me to express myself. The rosary, the most feminine of female spiritual practices, was prayed with bent head, hands holding the beads in a posture closing off the front of the woman's body. While in Mexico, I decided that when I returned to the United States—to Arizona State University where I worked alongside some of the nation's leading scholars in performance studies—I would perform an embodied rosary as a way to further explore the cultural themes.

As a form of inquiry, performance at once took the ethnographic gaze from the "auto" to the social. Immediately I realized that the communal aspect of the cultural transmission of meaning in my life had been left out through emphasis on my own interpretation of my experience without the input of others. My experience as a woman of Mexican ancestry is all part of the social fabric of communal meaning. If I was being given insights into a reality that was true for me, then it had to ring true for others of my ancestry as well. I knew that to plan my performance alone was not a good idea. So I offered the opportunity to work with me on the project to friends and students who indicated interest. A trio of undergraduate

and graduate Chicana and Chicano students committed to work with me: Anthony Hernández, Bernadette Calafell, and Elsa Gómez. Marco Albarrán, a Phoenix-based Chicano activist, writer and artist, volunteered his assistance as well. We began meeting and talking about the performance in August of 1999, reading books and discussing them together, talking about our experiences in universities and the confusion of identities with which we lived. I shared segments I had written and they gave feedback. By January of 2000, we had envisioned the embodied rosary—one that took us on five journeys into the mysteries of womanhood, by dedicating each journey to an aspect of life suggested by the images of Mary and the cultural-historical feminine icons to whom I had been writing. Elsa helped me choose music and text from my personal narratives to use as recorded voice-overs for the performance.

Additionally, I received input from my professional colleagues in ethnography. At the 2000 Conference of the Society for the Study of Symbolic Interaction in St. Petersburg, Florida, I performed the "Journey of the Heart," corresponding to the image of Our Lady of the Sacred Heart (Nuestra Señora del Sagrado Corazón), *La Llorona*, and my experiences with the grief of an unwanted abortion. I selected music for it and had my friend Buddy Goodall help me rehearse. For the first time in my life, as I heaved my body in grief and cried from the depths of my soul in front of over 200 friends and colleagues from the academy, I felt that I was finally owning my embodied life. What I discovered there was that autoethnography could serve a socially therapeutic function (Bochner & Ellis, 2002).[4]

That evening, I had scores of people, both men and women, tell me that my performance had touched them and moved them to a place of healing. I had women not of Mexican ancestry tell me that as women raised Catholic, they felt the power of my de/reconstructed prayers to Mary. I had men tell me they had never dealt with their own grief over the abortions of their partners, thanking me for validating the sorrow of the politically correct act of "having the right to choose what one does with one's body." I sat on a deck overlooking the Gulf of Mexico as the sun was setting after I performed that day, not realizing the symbolism of watching the sun set over the horizon of Mexico. And I felt for the first time in my life, free in my body. I had no shame. I was not afraid to touch or be touched. I discovered in the very flesh of my body, depths to the themes I had before reached. I would continue to perform *María Speaks: Journeys through the Mysteries of the Mother* at Denison University in Ohio, at the Empty Space Theatre at Arizona State University, and at the University of Creation Spirituality in Oakland, California. At each site, I engaged the audiences in discussion after the performances, using the trigger-scripting methodology developed by Valentine and Valentine (1983). Their responses, along with my embodied awarenesses as I staged my 90-

minute, one-woman performance each night, continued to enrich the data this human instrument was collecting and preparing to share in writing.

Interpreters Theatre and The Hugh Downs School of Human Communication at Arizona State University invite you to experience

JOURNEYS INTO THE MYSTERIES: REVEALING THE MOTHER IN THE SHADOWS OF MEXICAN WOMANHOOD

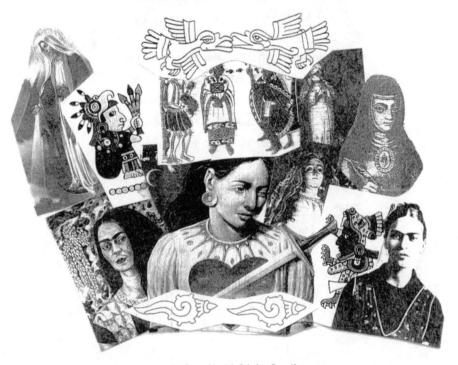

Performed by M. Cristina González

Saturday, April 15th, 2000 7 p. m.
Sunday, April 16th, 2000 2 p. m. with discussion following

Empty Space Interpreters Theatre
9th St. and McKemy, Tempe
(map on reverse side)
Admission is free. To reverse seats please call 480-965-3773
Seats are limited.

Flyer, 2000 Performance of *María Speaks*

AFTER SHE STOPS, SHE TURNS TO IMAGE OF
OUR LADY OF THE SACRED HEART AND
STATES HER NEW PRAYER TO THE
IMAGE...PICKS UP ROSARY FROM FRONT OF
THE IMAGE AS SHE FINISHES.

STANDS CENTER, FACING AUDIENCE, HOLDING
ROSARY VISIBLY...

"What do I do with THIS?...throughoutin the
Church our disagreement or dissension is used as
grounds for why we should stay a part of the
Church...oh don't go...we NEED people like you...
throughout my entire life I have felt a deep sense of
the divine in my life...and it never quite had anything
to do with the church-going life I led.
"Maybe it was because the one person I saw as most
connected to God and the saints was my grandmother

Script, Page 4

MUSIC DIES DOWN....REMAIN SEATED

TURNING TO LA DOLOROSA

"Maria...from the bitter herb...the mitzrayim...but if your name was miriam, or Mary...it was a Hebrew name...and in Hebrew, the name is all of the meanings of the sacred letters making up the name...Maria...Mem....Reish....Yod.....it is also Amira...also Omar...the words that mean speech...that mean expression. Oh, Maria...your name does not mean silent suffering one...it means one who speaks...out of the narrow spaces...I need you now, to show me how to do that. In the tradition of Sarah, Rebecca, Rachel and Leah...the matriarchs of your tradition...Esther and Ruth and Tamar...the women who risked themselves to express and do what they knew to be true. Oh, Maria...I will never think of you the same way...patroness of sacred speech

MUSIC....AVE MARIA BEGINS WHILE CRISTINA STANDS,CLEANS UP PAPERS AND PROPS \

Script, Page 13

Here is my connection to all things

I am SHAPESHIFTING WOMAN

I am Chicana

And with the word...I become Mother...

Freeing myself from the narrow spaces

Of politics

Race

Religion

And people

I give birth to myself

MOVE TO ALTAR OF GUADALUPE AND LIGHT

THE TWO BLUE CANDLES

BEGIN SLOW PROCESSION/MOVEMENT

Script, Page 20

2

The Autoethnography

I stand before you, *madrecita*
Tonantzin
I stand before you
with all the nakedness of my life
revealed in the scars on my
human mind
the scars within my body
revealing the memory of my soul
sinewy limbs from
the efforts of a life of human
shame
to find the leaves
the right dance or verse
to cover this nakedness

I stand before you, *madrecita*
Tonantzin
I stand before you
weary of the effort

and wanting of new eyes
wanting of Your loving eyes
when I look upon my life
I want to see
without the blinders and veils
of all that has kept me from You.

I stand before you, naked,
madrecita
Tonantzin
I stand before you
scarred and ready to walk
head held high
uncovered scars proudly on
display
signs of my divinity
of my creation
as Woman
Tonantzin.

The Initiation

In 1987, I suffered a very fortuitous accident. It was in December, one year to the date from the day I had unwillingly "terminated" my first pregnancy. Walking

back to my office at Rutgers University from my apartment down the street, I remember stepping off the curb and looking at a car that was preparing to make a left turn. The light gave me the "right of way," and I stepped into the crosswalk. The car accelerated, and I kept walking. When it was about ten feet from me, I realized what was happening. I screamed from a place deep within me in absolute terror as I felt the car collide first with my left hip, then my knees, then my left shoulder as I began to collapse. Finally my chin and mouth and head were struck on the hood of the car, knocking me unconscious, and throwing me into the air. I landed about three yards in front of the car. Laying in the street, moments later, I regained consciousness, my body in shock, unable to move. I was in incredible pain. The first thought I had was, "I am still alive." I had thought I was going to die.

That winter and spring were long seasons of incubation and preparation during which I underwent grueling daily physical therapy for five months. I cancelled my coteaching of a graduate seminar because I was unable to speak, write, or think coherently for very long periods of time. The neuropsychologist in Princeton, whom I visited weekly, confirmed that I had a left hemisphere head injury. "Don't quit your job—you will want to. This will take up to three years to heal to its fullest level of healing." I received word that I had been granted a Fulbright award to Mexico. I went to a doctor who did not know of my accident, and I quietly sat through the physical tests so I could be given a health clearance to go. August of 1988, I was in the hands of the Mother—but did not know. It would take another ten years for me to recognize how my abortion in 1986, a violent face of my own motherhood, was the first step of the embodied rosary I would consciously walk today.

While I was in Mexico, I taught classes at the Universidad Autónoma de Chihuahua, at the Facultad de Psicología. I taught in Spanish. My head injury made it difficult for me to remember what I started, and words were slow to reach my mouth. However, the linguistic troubles were less pronounced in Spanish, since it is my first language. And the hospitality of my hosts saw my lapses in memory as simple problems with language translation because I was Chicana—Mexican American, and *pocha* (someone who can speak no language correctly, and a traditional insult in Mexico, the land of mixed-blood bilingual peoples).

I did not write anything but personal letters, my personal journal, and tedious translations of notes for my classes until Spring of 1989. I would forget about these until finding them months later. I read only for pleasure—my analytic and critical skills were hampered by my mind's inability to connect long-term and short-term memory, otherwise intact. I was being given a gift. I learned to learn by being present, to watch and absorb, to hear words without linking them to anything I'd heard before. I had no choice; I could not do otherwise. There was no such thing as

future or past in the mind I now possessed. Perhaps this is the way the mind is in the womb of the Mother.

For almost ten years I had been practicing ethnography in my professional life, by taking endless fieldnotes, interviewing, and organizing notes and transcripts into flawless categories and definitions. This is the way I had been schooled to study and understand culture. I now had to learn to trust myself to be what Yvonne Lincoln and Egon Guba (1985) called the "human instrument." I was still committed to rigor and accountability (De la Garza, 2003) in my work, but my head injury was awakening the part of me that knows beyond my mind or its emotions. It was a gift to have that road which travels from my soul to my understanding revealed as I woke. It would be the road on which the journeys of discovery and recognition of the mysteries of my life would be traveled. And when my abilities to travel to the past and future were restored, along with all my mind's learned patterns, scripts, and rules, this road would hold my feet in place while I endured the efforts of my mind to have me turn back. This road was the site of the embodied rosary I would eventually live.

I didn't know during that year in Chihuahua exactly what I was doing. I did, however, have a sense that whatever I was drawn to would somehow find its meaning in time. That was the gift of my head injury—this ability to wait for the meaning to come. I was no longer capable of supporting the belief that I was in charge of my thinking. Many of my colleagues in the world of university learning often lament the ways that our academic training affects our ability to trust the ways indigenous cultures and elders have taught us to know. Healing from the rigid socialization of graduate school was painful and difficult at best, maybe impossible at worst. My head injury did it for me in one fell swoop. My thinking had been transformed. I began to develop a deep and visceral understanding of the knowing at the base of indigenous spiritualities—in silence and without words. I was not in control—I never had been. Now I could neither deny it simply nor claim it arrogantly as a creed or philosophy.

My thinking thus turned to the life I was living. My study of culture, and beliefs about how it should be done, began to be transformed along with me. The notes and categories and literature in my young career as a scholar had been privileged as the source of insight and knowledge. Now I saw them as the tools to aid a deeper source of awareness and wisdom, which was integrally grounded in a material and rich subjective human existence.

Being only 31 when I went to Mexico in 1988 and rooming with a blonde, green-eyed 23 year old from England, who was also teaching in Mexico on a grant, my life was full of the excitement of an active social life. I experienced the expectations for women in social, romantic, educational, and business settings. As I

watched and paid attention, my inability to be dominated by my mind allowed my focus to emerge in its own time.

I began to understand that a vocabulary of a few repeatedly used terms for women seemed to capture the complex reality of what it is to be a woman of Mexican ancestry. Because I was living with my British friend, Lynda Whitehouse, the implicit nature of my understanding was made graphic each time I understood the implications of social actions which to her were alien. Although I was not born and raised in Mexico, I was becoming aware that Mexico had not escaped me. The labels for women in Mexico, used colloquially and in a taken-for-granted manner in the daily speech of Mexicans, were labels that I too had internalized. As a Chicana woman of Mexican ancestry, with a lifelong intimacy with Mexico and the Spanish language of my family and community, I had found the labels that corresponded to my psyche. I was discovering the sense-making apparatuses and identifications that made my mind work.

The words that were used as labels for women revealed to me that on the basis of four ideological themes, any woman could be determined to be either acceptable or not. Religiosity, sexuality, socioeconomic status, and race were the cardinal ideologies for being a proper woman in Mexico. I was not able to pursue the analysis of this material during that year in Mexico because of my head injury, however, when I returned ten years later, with a second Fulbright to Chihuahua, I did.

I arrived in Mexico in 1998, equipped with a transformed brain/mind and the life experience that this transforming mind had facilitated. During the ten years since the first Fulbright, I had turned to my indigenous native roots and began intentionally exploring and developing a conscious spiritual practice. My relationship with Roman Catholicism was problematic, and I'd begun to study Judaism, the religion of my Sephardic ancestors. I'd taught courses in intercultural communication and Chicana and Chicano studies at Arizona State University, and these courses gave me many opportunities to explore the issues that had raised my interest in 1988 and 1989. In addition, I'd begun formal study toward a doctoral degree in creation spirituality, helping me to break down the barriers to a wider and deeper experience of God.

Those ten years were not easy ones. The difficulty of dealing with a fragmented identity and becoming accustomed to a mind that would never work as it had caused me great psychological and emotional trauma. In 1994, at the peak of my confusion, I attempted suicide three times during a one-year time frame. The following year, I was married, pregnant, and miscarried. I followed that with a quick and short-lived attempt to return to Catholicism, thinking perhaps that was the "key." Nothing I had learned in life about God had prepared me to deal with my life as it was unfolding. I realized I did not know God, or if what I had thought of as God *was* God. Those ten years introduced me to the idea of the feminine face

of God, the Great Mother, as a real possibility and not simply a feminist ideal. These ten years were also preparing me to meet her.

Into the Liminal

The first month in Chihuahua, September of 1999, served as the vigil to this project. I lived in the home of a woman who was proudly the coordinator of catechesis (religious education) for the Catholic Diocese of Chihuahua. The fact that I wound up in her home was itself uncanny, since I had specifically asked that I not have to live in a home that was "too Catholic." My experience in the Church had already begun to deconstruct itself, and I knew I had quite a few triggers that could be easily pulled. I had forgotten the concept of *morosidad*—that yes can mean no; that it's considered rude to say "no" to a request in Mexico—had forgotten that requests should be made indirectly in sensitive areas in order to get a response one could believe. Oh well. I had been assured that the landlady was not very Catholic before I arrived. Maybe they thought I meant *catholic*—without the capital letter.

Over the month that I lived in her home, I received daily minisermons about religion, women, and "those women." I learned just how ambiguous my identity was. I speak Spanish fluently, I look just like the people of Chihuahua (three of my grandparents are directly connected to the city, and many distant relatives still live there), and I was raised the first seven years of my life within a segregated and insular community where Spanish was most frequently spoken. Before Texas gained its independence from Mexico, my hometown was in the same province as Chihuahua, and branches of my family had lived there since those early years. We were proudly "Mexican" in every cultural tradition. Despite these facts of my identity, my life had also taken me to live among other places, in New York, New Jersey, Maryland, and Chicago. I was far too direct, quick, and assertive in my speech style to be a proper Mexican woman. I dressed a bit too androgynously, wore little of the right sorts of makeup, and my hair was too frequently worn loose on my shoulders. I went places alone, including bars, and I walked everywhere even though I am not poor. I went to church, but I admitted to divorce and having lived with a man. I began to realize that the difficulty the people of Chihuahua had in placing me in a category was part of my own struggle with myself. I began to see that even though I intentionally disagreed with the implicit values of the ideologies of religiosity, sexuality, socioeconomics, and race that determined who I "was" in Mexico, I never struggled in understanding them. They were taken for granted in my primary cultural perspective—the very fact that I was conscious of my different stance implied that I'd had to learn them first. But was it possible that at heart, I was still determined by these intersections of ideology—as foul as I found them to be politically and socially?

In my heart, I came to see quite quickly in that first month with *La Señora*, that indeed I was. And that is why I got so mad when she took the money out of my hand when she caught me buying a bottle of expensive tequila for a birthday present. You see—I understood exactly why she did it. And even though I decried her "rudeness" and "gall," I never told anyone that deep down, I felt self-conscious and "bad" for being a single woman without a wedding ring, buying expensive hard liquor at a grocery store. Shortly after this confrontation, I moved to the hotel I'd lived in ten years before, until I could find another place to live.

The hotel, *El Campanario,* was named after the bell tower on a Catholic mission. There were antique paintings throughout the hotel, taken from the walls of colonial Spanish era missions of Mexico. The floors were hard tile, and sounds echoed through the carpetless corridors. It was like living in a convent—Spartan, but clean. Uncanny. Eerie, even, as I reflect back on it. It was the same hotel I'd lived in ten years before, but my friend, Katina, who had managed it, had since passed away. Her sister and brother-in-law now ran the hotel and had spruced it up a little, removing the paintings and transforming the ecclesiastic environs. At the hotel, I was friends with the housekeepers, the accountant, the manager, the cooks, and the maintenance man. Nights, I often found myself drinking beer with the manager's husband, or bootlegged tequila with the night cooks in the restaurant. Days, I'd enjoy coffee with the accountant and her friends, or a *limonada* with the waitress as we discussed herbal medicine, astrology, or tarot. Equally as often we talked about the saints or shared knowledge about rosaries or lighting candles for prayer intentions at the cathedral a few blocks away.

Although I could afford the hotel, I was running out of money. I was still an anomaly—neither wealthy nor poor. I bought books and ate at some of the more expensive stores and restaurants in town, but I also frequented the street taco vendors, local herbalists, and native healers. And I noted, through it all, that I felt the appropriate self-consciousness and guilt at every turn. I nodded my head simultaneously with women of all races, ages, and socioeconomic status as we talked. It was this implicit knowledge of the boundaries of what it is to be a Mexican woman that enabled me to blend. It also became more and more apparent to me that it was that same internalized sense of boundaries that allowed the flames of purgatory to burn bright red within me.

A Spiritual Autobiography

A Cradle Catholic. In many ways, before anything else, I was Catholic. A "cradle Catholic," I was thrown into the experience of seeing all my experience through the eyes of the Church from the moment of my baptism on March 31, 1957. I was just a little over two weeks old; I weighed about six pounds. I wonder what I saw.

Black robes with white smocks? Hats on my mother and godmother? Was there incense? I am sure my parents, grandparents, and godparents were talking to each other in Spanish. And the priest, Father Franchi, from Italy, spoke fluent Spanish too. Was I baptized in English or Spanish? Or since it was before Vatican II, was I baptized in *Latin?*

Godfather Bonifacio Gonzales, Godmother Asteria Urias, and Father Franchi

Grandfather Cosme and Grandmother Fina

Mother Senaida, Grandmother Carmen, and Father Alejandro

María Christina González

Baptism, March 31, 1957

It was the same church in which my mother and father had been baptized. They were married there. So were my grandparents and great-grandparents. My great-great-grandfather, Pedro Urueta, had helped to establish the church. The statue of Our Lady of the Miraculous Medal, *La Milagrosa*, was donated to the church by my grandfather, M. R. González. To be part of my family was to be Catholic and a member of St. Joseph's Church. If you were Catholic in Fort Stockton, Texas, you had to cross over to the Mexican side of town to go to church (until St. Agnes' parish was built on the other side of the railroad tracks).

Being Catholic was part of being Mexican. When we talked about God, it was a God in Spanish. But when we went to church, everything was in Latin. The priest had his back turned to us, so he couldn't see when my mother pinched me or dragged me outside to spank me for singing one of the songs I'd heard on the radio out loud. One time I supposedly sang out, "Hang down your head, Tom Dooley!" at one of the most solemn moments of the Mass.

My mom taught me songs to Mary when I was very little and those songs were in English, because the nuns were Anglo underneath their long black habits, and the nuns were the ones who organized the parish into the May procession that we did to honor Mary. We would walk in a circle around the park in front of the church with our flowers, and then we would take them to Mary. These experiences made me happy. We would sing the songs to Mary and everyone was in a good mood, and it was pretty and it smelled beautiful. "Immaculate Mary … Ave, ave, ave María … Salve, salve, salve Regina …." Latin and English, but no Spanish.

My aunt, Josefina, because she was married to my Tío Kiko, was picked to be my godmother when I was confirmed. I was only about three years old. You are not supposed to be confirmed until you are old enough to know what you are doing, but Father Franchi used to run the church like the old days. So Josefina, who I used to just call "Nini," because it was too hard to say *madrina,* took me to the church to talk to Father Franchi before the confirmation. I remember he had all these ladies in the house, and they were all laughing and talking in Spanish and treating Father Franchi like you treat a man—like he is the King.

I didn't like Father Franchi. When Nini was taking me home and I was supposed to say good-bye to him, he gave me a bag of that salt water taffy that came from somewhere else because nobody made that candy in west Texas. I usually loved candy, and was always getting in trouble for eating too much of it, but I didn't want the candy he gave me. I didn't say anything, and Nini scolded me and told me to say thank you. "*Dile gracias al padre,*" say thanks to the father, the priest. So I did. And I took the pastel-colored candy wrapped in wax paper.

I remember one time a couple of years later when my aunt Carmen (I called her Mamie) took me to Safeway to buy groceries and the lady who used to buy Father Franchi's groceries was there. Mamie told me to look in the basket to see that

Father Franchi ate T-bone steaks, while we, the people in the church, had trouble paying for our food. I understood this because, when I was four, my father left my mother for a couple of weeks after they had this big fight on Christmas. He took my sister with him and left me with my mom without money or food; the ladies used to bring us food, or we would walk on the dirt roads to Mama Fina's (my grandmother's) to eat. That's the way I experienced it. Maybe we did have money, but I was scared to eat too much, since I saw my mother crying all the time and she used to say we couldn't afford groceries. So I knew that it was not fair that Father Franchi ate T-bone steaks. But he was the priest. That was St. Joseph's for me. And God in Spanish.

We used to live at 500 W. Callaghan, in the "rock house." That's what we called it. But it belonged to my grandfather, Papa M. R., so when my dad got elected justice of the peace and started making $6,000 a year, we could get our own house. He bought us a house on the corner right across the street from the railroad tracks. That meant that I could go to Comanche Elementary, where I was the only Mexican in my class. (My dad said it was important that I could go to school there, since they had kept Mexicans out of the schools before.) But when we moved to that house on the corner of Gillis Street and Railroad Avenue, we moved to the world of St. Agnes. Where Vatican II brought me God in English, in a way I could understand. Where Father Franchi was nowhere around. And where the nuns from the May procession came to give me catechism.

> Doña Claudia gave me a rosary
> when I made my first holy communion
> when I was dressed in my white lace dress
> like a little seven-year-old bride
> with little white socks and shoes
> an inauguration to the mysteries of the women
> the mysteries of Mary
> the sorrows
> the joys
> the glory
> I was like Mary
> a girl
> who could be holy
> who could have power
> by finding herself
> in the life she gave to another.
> *Rézalo, m'ijita*
> Pray it.

Wheat and Tares

I have a really small rosary that was given to me by Doña Claudia, one of my grandmother's best friends, when I was seven years old. She gave it to me right after I made my first communion. Lots of people were giving me things then. My grandmother Mama Carmelita gave me a small prayer book in Spanish, with a mother-of-pearl cover and gold latch. My dad's first cousin, S. L. Gonzales gave me a little gold heart that was shaped like a sort of cage, and it had a single pearl inside it. Making my first communion was a big deal.

We were moving to Washington, D.C., from our little hometown of Fort Stockton, Texas. My mother and father, my brothers and my sister, all my aunts and uncles, and my two grandfathers were all born in Fort Stockton. Even some of my great-great-grandparents were born there. But my dad had gotten a job as a congressional aide in Washington, and we were going to join him up there in February. It was 1965. He had already moved after the November elections the year before, and it was a really exciting time. I'd grown up around Democratic politics and LULAC, the G.I. Forum. I was used to hearing the men talk about the offices they were running for or the candidates they were supporting. My dad had worked to get Congressman Richard C. White elected for the 16th Congressional District of Texas. My dad was the connection to the Latin American vote, as they called it back then. So when Dick White got elected, my dad was asked to go along.

Knowing what I know now, my dad was a wonderful opportunity for Congressman White to look good in the civil rights environment that was enveloping Washington at the time. My dad had a master's degree in political science and, in 1965, getting a graduate-educated, politically involved Mexican-American male who had already served in elected office (justice of the peace in Fort Stockton) was quite an opportunity. My dad thought he was going to make a huge difference for the Latin American people of southwest Texas. It wasn't until February of 1999 that I discovered what a disillusioning experience Washington was for my dad. When my mother was packing up to move into a smaller house, she gave me as many of the books in the house that I might want. In one of the books I found four manually typewritten pages that my father had written in 1965, evaluating his experience in Washington that first year. I never knew how disillusioned he had been, how he had been treated as a token Mexican, had been relegated to opening mail and omitted from key meetings and decisions regarding the Latin Americans in the district. I wish I had known that. It feels like it would have made a difference to me.

When I made my "First Holy Communion," I had to do it all by myself, because we were in a hurry to leave to Washington, and if I didn't do it alone, I would have to go without having made my "First Confession," too. Father Frey, who

used to laugh like he was nervous that someone was going to get him in trouble for being alive, gave me this little catechism book that was supposed to prepare you for your First Holy Communion. I can't remember the name of the Sister who helped me with it, but we used to have to go to the convent, by St. Joseph's Church, to meet with her, so she could ask me questions about the little book. My mom would take me, and Sister would come to the door in her long habit and smile really big and ask me to come on in. We were never allowed inside the convent before, but this was a special occasion—what I was doing. That's what I understood.

The main thing I remember about that little catechism book is that it had this picture of a big gray boulder, with two little kids, a boy and a girl walking along in front of it. Behind the big rock was this green devil, really ugly and just waiting to pounce on them. The lesson was that I had to make my confession and resist all temptation so that the devil wouldn't get me. Ultimately that would mean I could go to hell. And by being allowed to make my First Confession, I was being given the privilege of telling my sins to a priest so that if I died I could go straight to heaven, or at least just to purgatory—if I hadn't gone to confession right before I died. Then, I would just burn until those sins were burned away. What a deal.

My whole point is that I did what I had to do so I could make my First Holy Communion, and if I did everything, then it meant everyone would see me as a good little girl. That was important. Everything I did seemed to excite my mother a lot, like it did years later when I started my period and she jumped up, shouting, "*Mija!* You're a woman now!" rushing to the store to get me junior-sized Kotex pads and an elastic belt. Somehow her glee had a hidden meaning behind it that I'd never been let in on. But it made her happy, so I went along. Making your parents happy was also important.

I was very smart, so I did a good job of being a good little girl who could tell how she was really a bad little girl that could confess her sins so that everyone would be happy with her. The reward was that I could put on this lace First Communion dress and this lace hat that was sort of like a summer bonnet (we borrowed the dress, because we couldn't afford one, and besides I was just going to wear it once). If I remember correctly, I got to wear little white gloves too, and Doña Claudia was waiting at the back of the church with the little rosary for me. My father was in this part too—when I went to the communion rail with both my parents to receive the host. My biggest fear was that I would let the host touch my teeth, and we were not supposed to bite the body of Christ. I hated having everyone look at me. Years later it felt the same way at my wedding.

The best thing about the whole day was that little rosary. The beads were tiny, like little seeds, and the whole thing rolled up into a tiny bundle no bigger than an almond. It had this little silver flat crucifix on it, and Doña Claudia told me that I

could pray it every night before I went to sleep. My grandmother Mama Fina did that all the time. She had a big one that glowed in the dark.

I loved that little rosary. When the First Communion was over, and I had taken off the hat and dress, and everyone had gone home, and we were packing up our things to leave to Washington, I held on to it and kept it close to me. The beads felt special, and it was like they had a secret power like my grandmother's. Now I had one, too.

I wound up going to a Catholic school in Hyattsville, Maryland. We lived in an apartment where the backyard was a forest and where I picked flowers and wild strawberries, dug up clay, and took my discovered treasures to my teachers at school. I learned about God and how much He loved me, and how the best thing in the world was to be a Bride of Christ. Mother Mary Almeda and the younger nun who taught us religion showed us their gold rings. I remember the young one, because she had this look on her face that looked like she was already with God. It made me want to be like her. We learned more songs and did plays and learned French like the nuns spoke. The nuns were not always fair, and they did some pretty bad things sometimes, but I loved God a lot and learned that I could talk to him—especially in the woods.

When I was nine, we moved to Peru, because my Dad got a job with the Peace Corps, evaluating volunteers. He brought me books from the State Department on how to learn Spanish, and I used to read them over and over again, even the dictionaries. Moreover, when we got there, it was a great place. We went to Santa María parish in Miraflores, a district in Lima, for church. Sometimes when we were running late, we would go to the Franciscan Catholic school near the house that had a chapel. It was all in Spanish, and I didn't feel God there anymore, but He must have been there. Everyone looked so sad when they prayed. It reminded me of Father Franchi.

It was in Lima that my mom sent my sister Linda and me to a retreat with *the nuns.* It was at an enormous convent with big mansions. They let us share a room with another girl. We were the only ones at the retreat who were not Peruvian, but since we spoke and understood Spanish, it was okay to be there. But boy, were the nuns *mean.*

When we dressed, we had to stand behind this screen, because if we saw each other's underwear, it was a sin. And then we had to eat at these big formal tables and if we talked while we were eating, it was a sin, and the nun would slam the table beside you to make you be quiet, since she couldn't talk either. And we had to listen to these priests who came and told us all about how great it was to suffer. One of them said we could never make up for what Jesus did for us on the cross. I got in trouble for talking because I told the girl next to me that we should put our arms up until the priest stopped talking and *that* would be suffering. Luckily they

didn't ask me what I had said. They just wanted me to be quiet, because it was a sin to talk when the priest was talking. It seemed like it was always a sin to talk.

I remember there was one girl who kept crying after every time the priest talked or whenever we said the rosary or sat around being silent. It turned out that she was realizing how bad she was and that she needed to give herself to God and be a nun. So we were supposed to want to be like her. But she looked miserable, and I couldn't understand who would want to be a nun like *these* ladies.

And Then I Lost My Voice

By seventh grade, we had moved back to Fort Stockton, and my old Mexican friends from when I was a little girl laughed at me when I spoke Spanish because I was speaking with a Castillian accent like my Spanish teacher, Señora Alegre, in Peru. They said that I was a snob for the way I talked. And when I spoke English, everyone laughed because they said I talked funny—no Texas drawl, and with weird pronunciation from living in Maryland. When I went to catechism, it was some new kind of catechism, where we all sat around in a circle, and Father Sam from St. Agnes used to tell us what we needed to know. It was really boring. And I got in trouble for saying that Jesus was not a Christian, and so how come if we were supposed to be like Jesus, we had to be Christian? Father Sam said that Jesus was a Christian, and I kept my mouth shut, but I knew he was wrong. When a friend called to tell me how bad I was, I told her Jesus could not have been a Christian, because he didn't follow Christ. I told her that Mary and Joseph weren't Christian either, and neither was John the Baptist. I told her they were all Jewish! And she told me I was evil.

I quit going to church except for when they used to get together with the group from St. Joseph's, where they had this priest, Father Wilde (Father Franchi was dead now), who used to take the whole group to the movies. Then we would get together the next week and talk about the movie and what it meant. Father Wilde let you say whatever you were thinking, and he never told you that you were wrong. He would tell you what he thought, and then you could see his point and sometimes change your mind. So I went to religion class then. But I stayed away from Father Sam and didn't go to mass very much. My mom was really worried about me.

There were other factors related to my staying away from church. When I got to high school, my mom suggested that I take speech. My mother had noticed something—I wasn't talking.

When my family had moved back to our home town of Fort Stockton in 1969 after having lived in Lima, Peru, I was sad. The time in Lima had been mystical and powerful for me. Fully immersed in Spanish and a culture rich with

indigenous mysticism and history, I had found ways to express myself that felt totally natural to me. I joined a Girl Scout troop while I was there and, because of our proximity to rural sites of pre-Hispanic ruins, we actually went camping near the remains of temples and homes built by the Incas. The young woman who was our maid, Carmen Capillo Conde, was my friend as well—she was only six years older than I was, and she taught me how to weave baskets out of the multicolored dyed straw she bought in her native village of Huacho. Traveling to Macchu Picchu with my family, I remember the awe inspired by the majestic rainforests covering the elevated mountain peaks surrounding the ruins of the sacred site. I found a piece of ceramic, with painting on it, a piece of an old pot—the awareness that I was holding something that had been held centuries before in an ancient civilization made me want to stay there.

Only a few months after visiting Macchu Picchu, we left Peru, and I wept uncontrollably when we were leaving. We flew to Panama, where we visited some members of the Peace Corps who had worked with my father, and I remember being taken on a wild backcountry cab ride by a taxi driver who wanted us to hear a song he had recorded. He took us to some old *cantina* and ran inside the turquoise-painted building to have the owner play the record at full volume. My father, mother, two younger brothers, sister, and I sat in the tiny little cab, sweating in the tropical heat, with clouds forming overhead foreshadowing the storm about to wash the land around us. We listened politely to the raucous song, before my father gave him some money for the treat and asking that we be returned to our hotel.

A couple of days later we were in Mexico City, staying at the El Presidente Hotel, where they had an outdoor swimming pool on the fifth level. This is where my brothers Alex and Arthur, and my sister Linda and I would be allowed to go swim while my parents rested. I was in charge of taking care of them, so when it began to get cold as dark clouds covered the sky, I went into the dressing rooms to get towels for everyone. I was 12 years old, was about 4 foot 5 inches tall, and weighed no more than 65 pounds. I was wearing a heavy turquoise one-piece bathing suit over my skinny little body and was soaking wet, my prepubescent breasts barely visible through the wet suit. I felt good. The swim had been fun, and I enjoyed taking care of my brothers and sisters. It would be the last time I felt comfortable in my body for a very long time.

In that dressing room, a strange Mexican man dressed in a gray suit approached me. He was wearing a huge amethyst stone ring on his left hand, and he startled me as I came out of the locker room area of the dressing room, with three towels in my hands for Linda, Alex and Arthur. I greeted him as I had been educated to do when I met an adult. He asked me my name, and I answered, "Cristina." He proceeded to sexually molest me. Beginning that day, the primary

way I would talk with others would be to shut out the memory and to focus all my attention outside of me. Speaking with my inner eye turned toward my heart became terrifying—so I turned it totally to the scripts outside of me. I grasped the scripts of Catholicism and Mexican cultural values I had learned so well and I worked to be good so no one would know my secret—that I was bad, that I was dirty, that I had let this happen to me. Somehow, the sacrament of confession did not draw me into confidence—I did not see it as a place for healing, but punishment. The trauma reinforced messages from early childhood experiences and guaranteed that Cristina would be kept hidden. The next day I climbed the pyramid at Tenochtitlan, site of my ancestors' rituals and sacrifices, where young virgin girls gave their hearts to the Mother so the people could live.

This was 1969—there had been no movement to educate parents and teachers about child abuse or its signs and symptoms. No one in my life knew my secret. No one knew I would freeze at the sound or sight of anything that reminded me of my trauma, putting me at risk for further abuse for the rest of my life. In spring of 1971, while I was dressed in my Girl Scout uniform in El Paso, Texas, en route to Chihuahua, Mexico, with my Girl Scout troop, I walked from the Ramada Inn restaurant to my room to go get my purse. A man stopped me on the way, opening his hotel curtains to expose his fully naked body to me. The silence intensified.

Deconstructing the Cradle

My life has been characterized by my conviction that the flashes of freedom I'd experienced during times of creativity or contact with nature were more real than the experiences of fear and boredom, of harsh authority and dualism, and spiritual dearth frequent in my relationship with religion. Although I would join many groups, I never really became a full part of any of them, since doing so would mean buying into the limitations and constraints that would so rapidly become obvious to me. Being a good member of a group, particularly a religious group, seemed to always mean knowing when to keep your mouth shut. Not being part of a group, however, was to me the greatest form of punishment—the greatest sign that my unworthiness had been recognized. The price for that unworthiness was the agony of my solitude.

One of the first things that began to deconstruct itself was the basic meaning of catholic. I still remember when I first realized that *being culturally Roman Catholic is not the same thing as being "catholic."* My college friend, Kevin Keith, who later went on to become a Diocesan priest, spoke to me about the Apostle's Creed. I told him about my difficulty believing that forbidding non-Catholics from receiving communion during the Catholic mass was a good thing. We talked about the infamous, "the Church is not a democracy" perspective. He questioned

whether I was just being typically American and wanting everyone to participate, and I began to wonder what the ultimate meaning of the Church's practice was. Talking about the "ultimate meaning" was usually how we were silenced as Catholics, in my experience. But Kevin awakened me when he said that when he prayed the Nicene Creed, he was declaring his belief in one holy catholic church, one with no capital "C" in catholic. It was the first time I consciously realized that there could be a choice. For those first two decades of my life, the universe was largely a context in which all but that which was Catholic with a capital "C" was doomed. I'd learned in Catholic school that our Jewish neighbors were damned for having killed Jesus, and I knew it was wrong. Kevin's words began my process of consciously questioning my faith. The "capital C" Catholicism was still in command of the way I would think for a long time, but Kevin had opened my mind to a possibility that would keep my soul alive in years to come during the times when the structures of the institutional Catholic Church would function to destroy it. Maybe the church was greater than Rome. Kevin had given me the gift of hearing for the first time the voice of my heart in a louder and clearer volume than that of my mind. We talked about Vatican II and the many enemies to ecumenism that existed within the Church. I began to see that I knew little about the religion that had claimed me shortly after birth.

Years later, I wondered about those things when I would attend mass on the Pine Ridge reservation in South Dakota and the priest burned sage on the altar in an abalone shell, passing the chalice and host through the fragrant smoke. I wondered about them when he added the Lakota names "Wakan Tanka" and "Tunkašila" into the prayers to God. My heart said that this was what real ecumenism was about, but my legalistic little Catholic mind was wondering if he could get in trouble for calling on the Lakota Great Spirit and Grandfather.

Then there were those summers I worked as a unit leader at Mitre Peak Girl Scout camp at home in the Davis Mountains of Texas. We held services on Sundays for everyone, with no specific religion as a focus. We talked a lot about nature and used what we had learned about Native American respect for the spirit of the land and wind and all living beings. We sang songs of various traditions, we read poetry and verse, and sometimes we danced. And we did it outside most of the time. Sometimes I felt that this was the closest I ever got to God. But when I attended these ceremonies, I missed mass, so it was a sin, even if it was full of God. And we didn't mention Jesus, so that was even worse.

All of these and many more experiences led me on the path to realize that in my life, my real calling was an *ultimate call to de/reconstruction of my religious identity*. Throughout my life, when I would confront the tensions of the contradictions of the Catholic religion and practice, I had been told, "Oh, please don't leave … the Church needs people like you." I was told, "We know the Church has

problems, but that's because it's a human Church. The Church is no greater than its members. That's why we need you." It worked for a long time. Those pleas had kept me there through the years I worked in youth ministry and wrestled with the hypocrisy I felt and experienced. They kept me there when the priest of the parish where I worked told me that I had to make the youth program more "fun" because the wealthy, popular youth were going to the Baptist youth group, while all I seemed to attract were the unpopular, depressed, artistic, and prayerful youth. My program was "too much about prayer" for youth, he told me. I could have hundreds of youth if we had pizza parties and ski trips, spending thousands of dollars of church funds, and if I didn't talk so much about prayer. Instead, I ran the whole youth program on $500, but we walked the streets and talked to the homeless, had a Passover seder and shared our food with the hungry, had heart-to-heart talks on sexuality, and created art to represent the messages from their dreams. Truly my heart was weary as I wondered what this Church was all about. History told me that I was not facing anything new. I was Mexican, for God's sake … my ancestors were killed for their gold. And others were burned at the stake for being Jewish.

I wonder at times if the institutional church does not provide harmful scripts for leadership which are so historically engrained that to attempt to heal w/in the church when the church was the instrument of harm is illogical + not of God. God is most present to us as humans when we recognize where + how we allow God to be present, through acknowledgment. Hierarchical, authoritative love impedes the presence of God, especially when the injury is caused by that tradition. The response is learned helplessness. It asks us to deny our experience out of respect for the oppressor's need to forget or feel forgiven.

Page 06 (back) from Field Journal

Over the years, however, the one aspect of my identity that showed the most resilience, which resisted attacks and evidence to rebuke it, and which manifested itself in full regalia each time critical decision points in my life were reached, was the "Capital C" Catholic Cristina. Even my awareness of the spiritual truths of ecumenism, of the power of nature and mystical practice to put me in touch with the ultimate One, and the obvious hypocrisy in the Church's policies and history were not enough to curb the legitimate power which the "C"atholicism within me wielded at every turn. My experiences of abuse only served to intensify this hold, with the deep sense of unworthiness and uncleanness caused by sexual molestation and physical and psychological abuse reinforcing the Church's teachings on original sin, purgatory, and hell. The flames of purgatory loomed in front of me for any false step. No matter how educated I was, no matter how much I could argue for another reality, no matter how drawn I was to other spiritual traditions or that I would choose to "leave" the Church repeatedly, it was "C"atholicism that called the shots.

The Spirituality of Deconstruction

I Begin to Think. The academic world had introduced me to postmodernity and deconstruction. I remember reading Michele Foucault (1972) and arguing with critical theorists in my field about a "deconstructive turn" that seemed really dangerous to me. I could not deny the need for it. The taken-for-granted is at the root of all we hold as real and of all cooperative action. To go back, like an archaeologist, in the language of Michele Foucault, and to find the origins of the ways in which we have constructed our realities—and through this deconstruction of the pieces to understand why it is we think as we do—this was fascinating. But what then? Do we remain fascinated, or become angry—do we expect recompense or accountability? All of these moves make sense and, depending on the situation, they can even be appropriate. But they are all based on who we have been, on what has been. Social action is based on who *we are,* and what is. Deconstruction makes us aware of the fact that none of the taken-for-granted is essential. It is all purposive or illustrative of purpose that has been. If we maintain our focus on the deconstruction, then so is our focus maintained on those purposes. Our actions, if in opposition to that which is uncovered through deconstruction, become competitive and dualistic. At some level, I was aware that simple deconstruction would endanger me. I needed something to heal me, not to simply take me apart for further understanding and critique. My academically trained mind helped me greatly, as my emotions were in collusion to keep me afraid of punishment.

As I moved along my spiritual path in life, I came to see that the obstacles and trials that I encountered were the constructions of centuries, if not millennia, of

historically purposive actions. My religion, my culture, and my family were all deeply founded on the constructions of the Roman Catholic Church. To look upon those constructions and to tear them down was to position myself in opposition to everything in my life that had created me as I am. If I deconstructed those institutions, I would be deconstructing my self. I would deconstruct the social, cultural, and religious being that I am. What then? Who would I be without a history?

Mar. 8, 1999
Chihuahua
San Francisco
Végù

I am feeling rather broken today. A Chihuahua occurred over the weekend. Sacred brokenness, from which I surface whole, but not constructed – and w/ no desire to be false in any way. No energy for it. But that is not a weakness. Just a door or opening to the energy which has been leaking in is closed — and I am able to start fresh. My fear is gone.

☆
nothing

Brokenness is a sacred state
It is the goal of all deconstruction
But its beauty is not in the defeat
of illusion o ideology or structure
It is in the absolute notherginess
+ vulnerablity, of being
in a state of total creative potential.
To be able to see how it is that the
choices are made. to exist
as a socially constructed being.
To see why I choose particular
structures again & turn from others
To understand more fully the
power of culture to call us
into being.
And to realize the
breath of spirit never stops
That I never die, even if "I"
cease to exist or change.

Page 29 from Field Journal

I believe that the reason that deconstruction in the Church is so difficult is precisely because of what I have just written. The Church is integral to who its members are, meaning that you cannot begin to tear apart what the Church means without tearing apart what the members mean. Even those who "leave" the Church, I am convinced, are semiotically constructed by its meanings, and the Church will continue to operate in the form of the personality structure of that human being. "The more things change, the more they stay the same," we often hear (Watzlawick, 1993). It could very well be that the only real change in human behavior occurs when persons move totally out of the frame from within which they have been viewing and experiencing the world. If the frame that the Church has provided is as resilient a frame as it has been over the last two thousand years, it seems that moving out of it would be a rather hard thing to do. Perhaps humanly impossible.

How incredibly distorted to get caught up in my own misery, my present circumstance, my history of past trauma, the politics of my life or the world. To lose myself to the realities of vanity or control or security. It is as if in the writing of my stories, whether they be based on my observations of "others," or my own life, or of the world that shapes my social being — I must beware. Beware. Be AWARE of how easy it is to give in to the illusion of insecurity, to the illusion of lost power, to the illusion of competition.

I was moved to tears today reading a quote of Etty Hillesum, at 26-years of age, in a German camp prior her transfer to Auschwitz.

Beware of the power of our pens to occlude this truth when recalling the miseries of our human existence.

Page 36 from Field Journal

And that is the point. It is humanly impossible. I believe it is sacred work. It is work that cannot be accomplished effectively without surrender to a power that is both unspeakable and greater than any reality we have constructed in our human meaning-centered existences. The political and emotional appeal of deconstructionist discourse can lead us to believe we are doing something "critical" and "essential." Some might even say it is "vital." But we say such things without looking at what the words imply. It is work that cuts to the very essence of what life is. I believe that, because we are dealing with the nature of the vessels for the human life force when we deal with our forms of social and human organization, we are engaging in sacred work—we are playing with the carriers of our souls. We are tearing them apart. I don't think we can (or should) do it with our minds alone.

When the Center Does Not Hold

We are doing this deconstructive work because these vessels, as constructed, are not functioning to allow our souls and spirits to connect with the "c"atholic community of which we are all innately members. But we need vessels. We are human. What happens after we have torn down the vessels that are not "working for us?" How do we find a way to go on existing in the social world of humanity? Where do we get our meaning? How do we use what we have to *re*-construct our vessels that we might better do our life's work? What is the source of the intelligence that can do the sacred work of reconstruction when our socially constructed minds have been torn apart?

In his 1990 examination of postmodernity, Walter Truett Anderson says that when we recreate new things, we use pieces of the old. It is that way in nature. Nothing grows out of something that has not somehow already existed. Reconstruction as sacred work will use the pieces of our shattered deconstructed existences to create a new vessel for the presence of the Divine. Because we have distorted the nature of our essence through the construction of constraining vessels does not deny the sacredness of our being. Every piece of our lives is a divine gift with potential to take us to God. Religion can interfere with this process by defining God so that even the very word can be an obstacle to contact with the Divine. If in deconstruction we destroy our lives, we are destroying many avenues of connection to God, but often opening them as well. Nothing is truly our enemy in the greater, grander scheme of things. The reification of something or someone—material, symbolic, or emotional in nature—such that we focus our attention on destroying it rather than embracing it as an avenue to God, will always come back to us in a damaged, distorted form with which we will have to deal. We will take wrong turns that will keep us separate from God. So I say, be careful with deconstruction. Proceed, but pay attention to what you are doing. We're going to have to

use those pieces of ourselves to come back together. If we have battered or dehumanized them all too entirely, we will be left with shattered vessels we will not recognize enough to see their sacred nature.

Another aspect of deconstruction as a sacred activity is the necessity for compassion for ourselves. Because the deconstruction of our spiritual legacy has deep implications for who we are and have been, I believe it will invite us into deep spaces of awakening and mourning when we recognize that there is no real duality; all healing and reconstruction will ultimately take us to the One. Deconstruction will lead us to see that in our own ways we have functioned to keep alive the illusion of separation within ourselves. There has to be room in the process of deconstruction for expressing the anger and pain and allowing it to breathe so that it might live as compassion for all we have been and will become. We have to learn how to let the breath of God breathe through us when we are torn apart. I think it is dangerous work—much too dangerous for people to be encouraged along the deconstructive path as if it were merely another historical venue, political agenda, or analytic project. It is the work of God.

Studying what he has called creation spirituality, Matthew Fox[5] has identified, through his translations of the work of Meister Eckhart (Fox, 1983), a schema for the spiritual journey that he calls the "four paths." He calls them the via positiva, the via negativa, the via creativa, and the via transformativa. I would like to share the way I have come to understand these four paths as they came to apply to the autoethnographic work in which I engaged.

Deconstruction is the function of the Via Negativa, an experience of the negative, experienced organically, in its raw uninterpreted form. The distortion of many spiritual values has served to distort the nature of this sacred path—of not so much *darkness,* as we so often speak of it, but of *nothingness—of the negative.* When we deconstruct, we are intentionally walking into the negative. And although we might have spoken disparagingly of the institutions and meanings we are deconstructing, that does not mean we will find this nothingness comforting. When Meister Eckhart prayed, "God, free me of God," it was not just a profound platitude or clever rhetorical ploy. It was the prayer of *hanbleceya,* of crying for a vision, in the pit of the earth, without any food or water, with no other persons around, no fire or blankets—nothing. The wisdom of the native peoples, such as the Lakota who call their vision quests by this sacred name, is in knowing that by willingly entering the pit of nothingness, a vision will come. Faith in the process is what sustains the seeker. And when we are in the midst of nothing, the life-sustaining act *is* to seek. To seek in the midst of the anguish of nothing, to seek because we believe in the great nothingness, the *Ayin Sof* from which all things are created. And somehow, in that misery of nothingness, we can come to love and cherish the mystery of our fragile, feeble little selves.

These selves that we deconstruct are the temples of Spirit. We realize, in that nothingness that results from deconstruction, that we need vessels to feel alive. We see that, as humans, the only thing that proves we are here is our selves—the selves we have constructed historically and culturally and which we are deconstructing. The impulse can be to camouflage these old selves and say we have reconstructed them, but to function with the same old rules and structures. We *need* boundaries in order to exist. The challenge of the Via Negativa, of the vision quest, is to surrender to Spirit, to trust that the freefall into nothingness will bring the vision and ultimate reality of the new vessel, one to which we can commit with renewed awareness of the One who lives within it.

The path of creating a new self, of reconstructing the vessel that had been sustained by the institutions, cultures, and beliefs that are deconstructed, is one that requires faith in the process. And a belief that there is a divine source of continued insight that will provide the wisdom for piecing together the new vessel. In *Stalking Elijah,* Roger Kamenetz (1997) suggests at one point that perhaps we are never truly broken vessels. The act of reconstruction would then be not so much an act of putting broken pieces together into a new vessel, but rather recognizing the vessel that has always been there but which the constructions of our social world have occulted and distorted. In the act of reconstruction, armed with the compassion for humanity that comes from an experience of the dark, we can understand what those fears and insecurities are that tempt us to distort our divine nature, our divine vessels. In recognizing these, we are better able to address them rather than to identify with them once again.

The Via Transformativa is the path we walk when we no longer identify with the fears and insecurities, the "suffering" of this human existence. Our vessels are recognized as intact, and the cultural, institutional, and social shrouds we once wore are no longer taken as the evidence of who we are. Our actions and speech reflect this new awareness and, therefore, our participation in the society around us calls for transformation. We become mystics and prophets—not because we have found anything new, but because we have learned to recognize our true nature and Source. This recognition or remembrance is the fullness of the Via Positiva, the path of awe and celebration.

Rather than seeing the Via Positiva as separate, I believe that when the Oneness of all is realized, we can no longer separate awe from the other paths. Awe characterizes them all. We learn that joy and celebration are about more than simple happiness with circumstances or the ending of suffering as we have known it. We can come to understand that the joy of mystics upon describing their "dark nights" is not a form of masochism, but an integrated spirituality—such as that recognized by Andrew Harvey (1994) when he tells us in *The Way of Passion,* that there comes a time when we will laugh in the midst of the insanity and pain.

I see the four paths of Creation Spirituality like a flowering plant. The plant is rooted essentially in the darkness; its very life begins in darkness. But this darkness, this negativa, is forever in the companionship of the positiva, the radiant light and nurturing air inviting the seed to birth itself in the richness of the dark soil. This lovemaking of the light and dark bring forth new forms, the creativa, which by its very essence transforms the context in which it blooms and grows: the transformativa.

When we do not recognize the beauty of this unity and its resonance with something deep inside, we can be led to an unintegrated experience—a sense that the paths are somehow compartmentalized or a progression of steps. When the four paths are integrated, there is no need to seek quick-fix ecstasies or to run from the pain of nothingness. When the four paths are integrated, there is no time that is not a time for creative action, no time at which transformation is not radically invited and celebrated. The four paths are like the Four Winds of the Four Directions—there is no boundary between them—the beginning or end of any wind is undefinable. And that is what my vision of postdeconstructionist spirituality and identity is. It is one where the "C" loses its power to reign because it cannot stay afloat on the incredibly rich and powerful river of truth *on* which all our vessels sail and *from* which all our wells draw.

Once in this place of integration, the nature of our work and existence becomes reinvented—new air is breathed into its essence. I came to this place not simply through a sequence of life events, but through an intentional process that I am documenting here. This abbreviated spiritual autobiography provides a context for the journeys I envisioned and which allowed me to reinvent the ways in which I conducted autoethnographic research, the way I studied my own life to understand my culture. This life becomes the site of the five journeys of the embodied rosary I have lived and that I believe we all live.

3

The Intentional Journeys Begin

I Want to Be Bernadette

The corner in the ceiling remained blank no matter how hard I squinted, no matter how long I remained on my knees by the side of my little twin bed. I was not Bernadette. And the vision of the Lady was not going to appear to me. No Immaculate Conception, no rosary, no magical waters flowing up through the ground to heal me or anyone else. But I so wanted to see Her. Truly, God, if I prayed hard enough, wouldn't she appear?

When I was 8 years old, I saw the movie, *Song of Bernadette,* the account of St. Bernadette's visions of the blessed Mother in Lourdes, France, or Our Lady of Lourdes, she is sometimes called. "I am the Immaculate Conception," she called herself. And she asked that the young girl Bernadette pray the rosary. When I saw that movie, I was a third grade student in St. Mark's Catholic School in Hyattsville, Maryland. I was a good girl. I made the highest grades on almost every assignment, I read at the level of a high school freshman, and read 55 books that year, much to the joy of my teacher, Mother Lena Marie. I could greet the nuns in French in the corridors of the school, and I turned in all my assignments on time. I wanted to be good. If I were good enough, maybe then the Lady would appear to me.

Those prayers I said, my little bony knees hurting from the hard bedroom floor digging into them, my tiny knuckles clutched in prayer, were heard. But I was a human being, a little Mexican American Catholic woman in the making, even then. And to answer the prayer, a lot had to happen in my life so I *could* see the Lady.

It is often when we have forgotten the intensity of our prayers and pleas, when we lose ourselves to the beauty of a natural moment, that the breakthroughs and insights in our life occur. On a sunny, breezy afternoon in February of 1999, in the Colonia of San Felipe in the city of Chihuahua, Mexico, I was walking to the dentist's office. Everyone was at work, the streets were bare, and none but the gardeners were visible as I walked with my backpack, noticing the flowers that had bloomed where there had been none days before. I was thinking about what I might want to do after my appointment. I thought about going to my favorite bar at Sanborn's where the staff had gotten used to this Chicana from the United States who drank beers or tequila with her food and sat for hours writing in her journals. I thought about the "project" I was supposed to be working on while in Mexico on my Fulbright and the notion of the "Great Mother." I felt the sun on my face and began to wonder how I was going to be true to my "purpose" in writing about her.

I thought of my little-girl prayer to see Her and how it had never been answered … and suddenly I felt my face open up. I realized that, in fact, my prayer *had* been answered. She came. But in order to see her, I had to live through the times in my life that brought me to the point of breaking. I had to live through the shatterings of my illusions and identity that were in the way of my vision. I saw Her. Only this time, She was not "out there," as in all the stories. I wasn't thrown to my knees, I didn't smell flowers or hear music. My heart burst inside me as I realized She was in *me*. She *was* me. And again, She brought the rosary, although in a very different fashion than I'd learned through life. I kept walking. This rosary is made up of the steps of the journeys in life. And in this piece of writing, I share how those steps reveal the Mother in my life.

The Mysteries

As Catholics, we are taught to pray the rosary as a way to reach Mary, the mother of God. The traditional posture for prayer is to be on our knees, with the beads held before us in prayer, our heads bent, or with an occasional glance up at a statue or picture of Mary. The rosary is about the mysteries in the life of Mary. Joyful mysteries, sorrowful mysteries, and glorious mysteries.

We are supposed to remember particular mysteries on particular days as we pray the rosary. Each rosary is made up of five decades of ten prayers (Hail Mary's) each. Each decade of each mystery is dedicated to a particular event in the life of Mary.

Imagine me, or any other little girl or boy for that matter, being given a rosary at around age seven, and the initial excitement at holding the beautiful mysterious beads. Imagine then this same child learning that she was not only to memorize

several different prayers, but that each specific prayer corresponds to particular beads on this beautiful rosary—that these prayers should be said in a particular order and that, each day when she prayed them, she should be keeping a particular mystery in mind, switching events every ten Hail Mary's around a holy string of 60 beads. Imagine a child doing this. Imagine it—for I do not doubt that it rarely happens. Instead the child learns that when she is praying with the rosary there is always a better, more correct way to be doing it.

When I began writing about this, I called my mother Senaida in Texas:

My question:

Mom, can you remember what the mysteries of the rosary are?

My mother's response:

Los misterios?
Los misterios gloriosos, los misterios dolorosos...
Oh! I can't believe I can't remember them
I was just sitting with Father the other day...
Let me see...
Los misterios...
I used to have a holy card with them on the back
Can I call you back after I look for it?

My mother's response to me when I called her as I sat trying to remember the mysteries is telling. She prays the rosary faithfully—maybe not *correctly*, but faithfully. That seems key, somehow.

While I was living in Mexico in 1998 and 1999, I visited a multitude of Catholic stores that sold religious items. There were a number of different, nontraditional, rosaries, such as the rosary to "Our Lady of Tears." This particular rosary has more beads on it than usual, and they are tear-shaped. Instead of decades of beads, the beads are arranged in groups of seven. I bought a small booklet written to explain how and when it should be prayed. This rosary made me remember the rosary my friend, Father Wilde, made for me when I visited him after my first year of college. It has all fifteen decades for all three sets of mysteries on one really, really LONG rosary, in three different colors. I still have it. I've never prayed it, but I've kept it—knowing that somehow this reverence of mysteries was important. But in the twenty-five years since he gave it to me, I've always felt confused by it and a little guilty of my ignorance of the "right way to pray." The rosary brings comfort to

many, but I assume that in most cases, it has done so for persons who were technically praying it *wrong*.

Los Misterios Gozosos (The Joyful Mysteries)

Lunes y Jueves (Mondays and Thursdays)

La anunciación: The annunciation
La visitación: The visitation
El nacimiento de Jesús: The birth of Jesus
La presentación: The presentation
Jesús encontrado en el templo: Jesus found in the temple

Los Misterios Dolorosos (The Sorrowful Mysteries)

Martes y Viernes (Tuesdays and Fridays)

La agonía en el huerto: The agony in the garden
La flagelación: The flagellation
La coronación de espinas: The crowning with thorns
Jesús carga su cruz: Jesus carries his cross
La crucifixión: The crucifixión

Los Misterios Gloriosos (The Glorious Mysteries)

Domingo, Miercoles y Sábado (Sundays, Wednesdays, and Saturdays)

La resurrección: The resurrection
La asención: The ascension
El descenso del espíritu santo: The descent of the Holy Spirit
La asunción: The assumption
La coronación: The crowning

The mysteries of the rosary from my
mother Senaida, reading her pamphlet
to me over the phone, April 2000

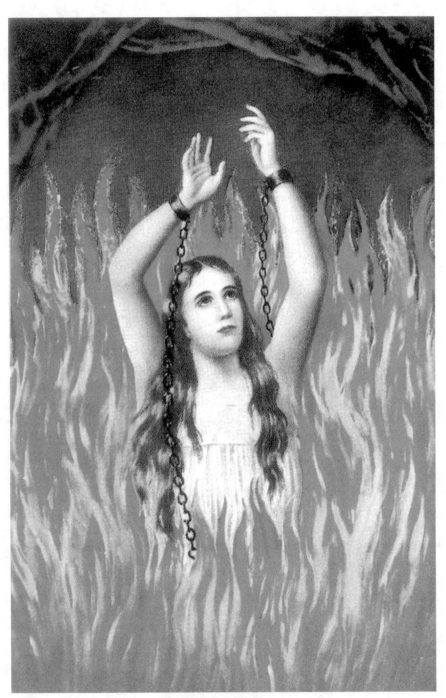

Lone Soul in Purgatory

Finding the Rosary in My Body

We were told that when something was bothering us, when we were troubled, when we were hurt or lost, when angry, or simply wanting to fall asleep, that the appropriate response was to pray the rosary. I tell my students that, when a symbol loses its connection to lived experience, it becomes purely cognitive and loses its creation-centered power. I don't know how the rosary actually came to be—it is such an ancient form of prayer and is not even exclusively Catholic. But when its prayers are not connected to our lives, they become rote, they become dogma, and they become empty. In my life, I prayed the rosary to be good, not to connect to anything I actually knew. That is what I came to seek in my life: spiritual practice linked to my very existence, not to who I wanted to be.

If that was the key to finding some sort of connection to the Mother, the Lady I had tried to see as a young girl, I figured I could do it. "God never puts a desire on our heart without giving us a way to make it happen." Isn't that how it goes? Of course, we're supposed to be able to tell the difference between a desire of God and one "not of God." My trap in life has always been one in which my desires have been tangled up with ropes of obedience. I was socialized into a fear of the flames of purgatory which are supposed to engulf me if I have made any mistakes I forget (or am unable) to confess before dying. It always seemed cruel, this idea that if I didn't know something was "wrong" and didn't confess it—or if an accident happened to kill me, I could still burn after a lifetime of being "good." But then God was my *father* and, if I looked at the outbursts of my father when he raged at my mother, then, of course, expecting rage and irrational attacks would be normal with God the Father.

The Mother was more confusing. The aggressive outbursts of the Father, centered on how our behavior has violated the nature of His existence, are easily identifiable. The Mother in Catholicism, as I learned it as a young Mexican American girl, seemed to be portrayed not as a jealous, vengeful, entity, but someone long-suffering, someone eternally sacrificing and giving. Therefore, it was hard to understand how a mother's outbursts could be motherly. Then a mother is a woman, and I was a girl, who would grow up to be a woman. My mother's outbursts toward me were all part of the reason we needed the Father—and that perfect Mother. It didn't make sense to me.

In September of 1998, I visited the cathedral at the Zócalo in Mexico City. The Zócalo is the meeting place located at the site of the ancient Mexica (Aztec) temple. Today it is the site of the government palace, some nice cafés, and the cathedral of the Roman Catholic Church. Whenever I have been there, I have walked into its hallowed shadows—there are never any bright lights in the stone building. It is cool and dark gray, and there are people throughout the cathedral,

praying at the various side chapels, all dedicated to specific saints. Each saint or image of Jesus or Mary is a patron of specific causes. On this particular visit, I was drawn to the chapel for the souls in purgatory.

As I neared the chapel, an elderly man seated in one of the mahogany-colored pews beckoned me. He had the look of those persons who have spent their lives working in hard physical labor. He looked as if he were about 80 years old, but given the pollution of Mexico City, combined with the labor of his life, he could have been much younger. His hair was dark gray, and he wore a white, long-sleeved shirt that was loose on his feeble frame. His dark slacks reached his huaraches (sandals) and he extended his hand to me. It was like the hand of my grandfather M. R.—dark, dry, brown sienna—with large finger nails soiled from work. "*Señorita, no me puede ayudar?*" He wanted me to give him some money. That was not uncommon in Mexico City, or for that matter, all of Mexico. I asked him what he needed the money for. I was unprepared for the response.

He told me that his wife's niece committed suicide. He then told me that his wife was unable to do what she needed to do for her niece. And to make matters worse, his wife died without last rites or confession; therefore, she was burning in purgatory. He had asked a priest to tell him what he should do to save her from suffering in eternal flames, and the priest told him that he needed to have a mass said for her. Every good Catholic knows that the way out of purgatory is either doing the time or having people pray for you to speed up your stay. I had seen a sign outside the rectory of the cathedral with prices for masses—it's been a while since I was there, but I believe the options ranged between a couple of dollars and ten dollars in Mexican pesos. Up to three days of paid labor for the "deluxe" Masses. He was sitting in the cathedral to wait until he received enough "limosna" to pay for the mass. I handed him a twenty-peso bill—about two dollars, and exorbitantly more than most people would give. He took my hand and kissed it. His hands felt smooth the way my grandfather's had before he died. The hands of a man who had worked hard with his hands his whole life.

He asked me what my name was. I was filled with compassion for this man, and I could barely utter my name without breaking into the tears that were welling in my eyes.

"María Cristina," he said to me, "I am going to pray for you for what you have done, for on this day my wife will leave purgatory." He held my hand tightly and I held my tears painfully. He told me I was a good person.

"*Que dios lo bendiga,*" I said, not knowing what else to say. May God bless you. He left to buy his mass.

I was enraged at the agony of this man. I went to a nearby chapel and sat and wept. For less than the price of a cup of cappuccino, I had freed a soul from purgatory. More significantly, I had freed this man for this day. I think that I also began

on that day, in the cathedral erected to commemorate the spiritual conquest of my ancestors, the actual release of my own soul from those daily flames. There is no doubt in my mind that his prayers for me would be holy, an awareness in my mind growing that the conquest perhaps had not yet taken place. There was still time.

My purgatory had not been one that waited for my death; it had been the burning mental agony with which I lived for nearly forty years. I longed to feel the freedom that my spirit and soul kept telling me was possible, but that I'd not been able to experience without terror.

Throughout my life I'd been known as a risktaker, a rulebreaker, and someone who seemed to say whatever she had to say. What no one knew is that because I chose to act in this way, to live according to what I thought was true, and to act out an assertive style, I lived with a constant fear of punishment for angering anyone to whom I had given authority over me. And, more tragically, I had never really expressed what was at my heart—my real truths. I had internalized two contradictory beliefs; purgatory was the inability to distinguish between the one that gives life and the one that brings eternal suffering. I believed that I should always tell the truth, but I also believed that I would be punished if I expressed my truth. Modern-day psychoanalysts would call this a perfect setup for a classic double bind (Watzlawick, Beavin, & Jackson, 1967). My belief in the insoluble nature of God, as I had learned Him, trapped me. The fear of repercussions for my actions and words throughout my life was crippling, and I was tired of it. I wanted, like this man had wanted for his wife, to find a way out of the flames of purgatory.

> I find the Mexican culture incredibly structured to reinforce my fears, although difficult to confront because of the Mexican myth of revolutionary people. The existence of the anger & sense of injustice does not itself heal the injustice. And the awareness of the negative repercussions for outspokenness or critique keeps people in their place, silenced, or at least acquiescently polite in their disagreement.
> Ni modo / no hay problema / no te preocupes / Sabrá diós / Si diós quiere / ... Tranquila, tranqui

Page 05 from Field Journal

Perhaps because of years of prayer, the awareness of the route to this freedom came to me as the conviction that it would come through the Mother—and through the rosary. Only this rosary could not be one that followed the rules. Like the rosary of Our Lady of Tears, which the woman at the bookstore in Chihuahua told me "was not approved by the Church," my rosary would reflect earnest prayers. My rosary would assume that power and relationship to the Mother are not intimate with orthodoxy. If this were the case, then maybe I stood a chance at freedom from the lifelong bondage to doctrine and religious technicalities. After all, in the Christian New Testament, when Jesus told Mary at the wedding of Cana that it was "not yet his time," she pretty much said, "Yes, but you have to do this NOW." This woman was not about technicalities—she wanted the sacred mystery of marriage to be full of the celebration that comes from drinking good wine and plenty of it. It didn't' matter if her son—the Son of God, messiah or not—said it wasn't time. There were other things more important than protocol and assumed authority. *This* is the woman I wanted to see—*this* is the woman I wanted to know.

So I set out to pray my own rosary—one whose beads and prayers would be the footsteps of my life. The mysteries would be the journeys I have taken and continue to travel. My whole purpose was to see the Mother. That's what I'd been trying to do since I was eight, since I saw the image of Bernadette looking at the Immaculate Conception. She told Bernadette to pray the rosary. I wanted to see her. So I started by trying to figure out what it was I was trying to see and why it would be important for me to learn to pray the rosary—my own, embodied rosary. I had to figure out what those mysteries were all about. I had to learn to see what the cultural blankets covering me all my life had been covering. So I started by looking at the life I'd been living.

Part II

Journeys into the
Mysteries of My Life

4

Journey of the Heart

Our Lady of the Sacred Heart

oh most terrible wound
ever-present on the journey
iron nail sharply thrust
finding its rest deep in your heart
inevitable aching
with every breath
with every heartbeat
the eternal memory of a Mother's
love
mysterious reasoning of nature
never to forget

what would happen
Oh Mother
what would happen
if we pulled the nail from your
heart

would it help you
would it hurt
would it make the past less
present or
do you love it
do you need its ever-present pain?
the gentle wreath of roses
sending sweet aroma
tender petals of fragrance
surrounding the wounded
oh so sacred
heart
your hands showing the way to
the freshly scented flowers
on life's thorny path.

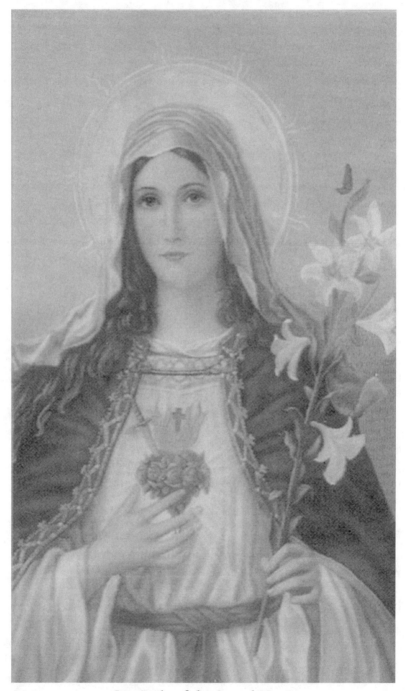

Our Lady of the Sacred Heart

Stories of *La Llorona*

It is difficult to grow up Latina, to grow up Chicana, to grow up *Hispanic,* without hearing the stories of *La Llorona,* the weeping woman who goes about at night crying because she lost her children. Some say that she is crying because her children were killed, others (most of the time) that she herself is the one who killed them. So she goes around at night wailing and crying, looking for them. A really popular version is that she drowned her children—so if you are near water, it is more likely that you will find her passing through the night. Or near a cemetery—maybe especially where the graves of the innocent souls are found. Those innocent souls are the babies who have died before they were baptized. They go to Limbo. That's what I learned as a child, and I'm sure many others learned that, too. You see, an innocent soul like a baby, still couldn't make it to heaven without being baptized. The Church was firm on those things. I always thought that made no sense. I still think it makes no sense. But I guess the Church has to be sure that we are doing the right thing, not making sense.

Anyway, *La Llorona* cries at night, crying for her children, as a sort of eternal punishment for her crime or loss, depending on how you look at it. If it is a crime, well, then she is damned to suffer because of her evil actions. If it was a loss, then she is damned to suffer, I guess, because she is a woman and that is what women do when they have children: Suffer. This is not book-truth, not historically documented narrative truth. This is the kind of truth you make from hearing stories. This is the way my mind worked at making sense of the stories.

When I went to college, I heard that the stories of *La Llorona* were about Malinalli, La Malinche, the woman who was the lover of the conquistador Hernán Cortés in Mexico. And that she was wailing because she created us—chicanos, mestizos—and was eternally sorrowful for what she had made of us. What a destiny. To know your cultural mother felt bad that you were born. Well, that made sense to me, in a way—not because of my own mother, but because my grandmother was always bemoaning her poor sons and daughter, my brother, my cousins … any of us who had been born looking a little too Indian. But the version I learned in college, and I don't even remember from whom, was not that *La Llorona* was crying because we were too Indian—I think it was because we were too *Spanish.* One way or the other, something was wrong with us. Nice legacy, no?

So, *La Llorona* goes about weeping and wailing and it is a terrifying thing. Since she was such a rotten mother, she would probably do rotten things to us if we were outside and she came around, right? That was the idea. So if it was dark, or we were misbehaving, we'd hear the wind outside our windows and someone would say, "*ahí viene La Llorona,*" here comes *La Llorona.* And we learned to be scared and to wonder … after all, somehow her story made sense, couched in the realities

to which we were born as little *chicanitas* and *chicanitos*. So that is where I begin this journey of the heart—by exploring my relationship with this woman with a broken heart because she killed, drowned, or somehow managed to lose her children.

Letter to *La Llorona*

Estimada…

Wait—it doesn't feel right to talk to you like that, to say, "Dear *La Llorona*," "*Estimada Llorona.*" It's like calling you names. You don't even have a name, and we think we know you so well. But we don't. I guess that's why I am writing you this letter.

Primero, te quiero decir, I want to say that I know that they say you come from all over. Some say you're not even *Mexicana*. But I'm writing *La Llorona,* and I just want to make sure that you know that I don't care where you're from. It's not that I don't *care,* but that it wouldn't change what I have to say to you. *Estoy segura* that it is you, no matter where you come from or what stories they have told about you. You're the one they said would come and get us if we went parking at the cemetery back in the 1970s … they used to tell us that you would come and break the glass in the cars to get us.

Fíjate, you must have really known how to get around, because we even heard about you in Peru. I hope it didn't make you mad when I put on that big bag over my head to try to scare the girls in my cabin at camp by pretending I was you.

But you know what? I thought I saw you. Coming out of the desert. *Estabas muy flaca,* and you were wearing a black skirt and kind of a gray torn shirt. Your hair was all messy. *Y tu cara*—and your face was all worn out, like from crying too much, like if the tears left tracks on your face. *¿Fuiste tu?* Was it you? I told everybody you were there. It kind of made me scary, too. *Me diste poder.* You gave me power. I could make them do what I wanted them to do.

That's what I want to write to you about. About the way we use you, but never listen to you. Oh yeah, we hear you, in our heads. Some kind of screaming, "*mis hijos, mis hijos—¿donde están mis hijos?*" You're always crying for your lost children. But we don't listen to you. You scare us instead, and everyone tries to tell us to get away from you. So you won't get us.

¿Sabes lo que yo pienso? You know what I think? That they don't want us to listen to you because they're scared that you are going to hurt us, like kill us or anything … but they're scared you're going to make us hear your story. *Y que esa historia nos va a doler.* Your story will hurt, like sticking a knife in our heart. So, *es mejor,* it's better for everyone if we just kind of pretend that you don't have a story, and instead, we make YOU the story. *La Llorona.*

Ves, yo soy una Llorona tambien. I am a woman who weeps, too. I think I am a lot like you. Well, I don't know really—because like I said earlier, I don't even know your name or where you're really from. But I know what it feels like to have a pain so big in my heart that I want to cry forever. That if I cry out, I am afraid I will never stop crying—like you.

Sometimes, you know, it feels like I don't really exist. Like it would be easier for other people if I didn't have a name either. Because when I cry out about things that are happening, I think sometimes I scare people, too. *Y me dan la espalda como si no hubiera dicho nada.* They turn their backs on me, or worse, they look right through me, as if I didn't even talk. Maybe like if they are making me invisible. *Si no tuviera nombre,* well, *entonces,* well then if I didn't have a name—like you— then they could just say that the awful noise I make when I cry out the truth is just the wind. *Es lo que dicen, ¿sabes?* It's what they say. That the wind, when it makes a crying noise, that it's you. *Es la Llorona—ten cuidado.* Be careful, it's *La Llorona.* But be careful of what? That you don't listen too closely?

Se me hace que te hemos hecho una gran injusticia. A great injustice, that's what we've done to you. By turning you into a spooky story or a legend. Because I think you have a lot to teach us, *hermana.* Yes, I want to call you sister, and I want to tell you that you have a lot to teach us. *Hermana,* I want to thank you for never being quiet. For not pretending that you don't hurt. For admitting that you did something awful. *¿Por que es tan necesario ser tan buenas?* Why do we always have to be so good anyway? Everyone knows we aren't. We're just as bad as we are good. But we're not supposed to let people know we know. And you *do.*

When we are out there now and we are doing something that we shouldn't be doing—staying out in the dark maybe too long or keeping secrets—when we are supposed to get scared when we hear the sound of the wind blow by our windows when we are all alone, I think we should remember who you really are and what you are trying to tell us. *Que algunas cosas si duelen:* that some things do hurt so much that we have to cry out. That sometimes we feel like wandering out in the night, not knowing where we are going, but knowing that no matter what, we cannot stop crying out: *Admitiendo la verdad.* That we are not so perfect and that we know. That we know.

Y quiero que sepas algo mas, mi hermana. Could I tell you one more thing? I don't think you have ever hurt anybody like they say you do. You know, killing us for being bad or something. *No, lo que nos lastima,* what really hurts us is when we pretend you are not like us or that we are not like you. What really hurts us is that we don't listen. *Que no nos hacemos caso,* that we don't pay attention to our own pain. And we pretend we don't do things that wind up hurting us and everyone else, *porque* somehow we are supposed to always do things right. But we don't, do we? *Y tu lo sabes.* You know that.

If you killed your children, well, I guess that really is something that would hurt forever. We've all done such things. I know I have. But maybe, just maybe, *si nos quedábamos en la oscuridad y escuchábamos el sonido lamentoso del viento,* maybe the pain in our hearts from all our secrets would start to heal. Maybe we need to stay in the dark and not run from that eerie sound of the wind. Your voice. Your cries.

Eso es lo que voy a pensar ahora cuando me hablan de ti. That is what I am going to think now whenever I hear your … well, when they talk about you. You don't need a name. You are every one of us.

María Cristina

When I Learned Why *La Llorona* Cries

It was a dreary day in December, a New Jersey late autumn day—cloudy, gray, and cold with a feeling of motionlessness. I was wearing a blue cable-knit sweater with a white turtleneck, and a pair of Levi's 501 jeans, with brown Eddie Bauer boots with rubber soles. I carried a gray down jacket, not really feeling the cold enough to put it on, but "just in case" it got colder later. He drove me in his car. When we got there, there were some people outside the dark brick building carrying placards I did not look closely enough to read. They were shouting out things that I have blocked from my mind. No one approached me personally, and I walked, in a daze, down the sidewalk to the building door. He sat in his car and waited until he saw me enter the building, then drove away. He would be back later to pick me up.

A month earlier, I had gone out to dinner in Little Italy with my sister's family who were visiting from Texas. I had ordered a plate of Fettuccini Alfredo, and I surprised myself by eating every bit of the huge serving, including all the salad and several pieces of bread with butter. "I can't believe how much I just ate!" I remember remarking. "It's all the walking we did," Linda reassured me. "Yeah," I agreed. But I did not feel full or stuffed.

Then, right before Thanksgiving, he and I went to a convention in Chicago. I wore a bright red corduroy dress that he had helped me pick out especially for the trip. On the night I wore it, we went out to dinner with some of his old friends. Again, I startled myself by eating all the steak and vegetables, a large salad, and bread (not feeling in the least bit full when I finished). But my clothes were tight, and I reminded myself to quit stuffing myself because I had to be putting on weight. My stomach was probably stretching from all the food I'd been eating. And here was Thanksgiving approaching, too! Not to mention my period was a few days late, and so I was feeling especially bloated and moody.

I found a health food store in Chicago and bought some beet-based capsules that were supposed to help you start your period if you hadn't yet. I took an extra

dose and then went shopping for a sweater. My clothes were all so tight, and I was feeling irritable. Nothing looked right. I found a beautiful burgundy cashmere sweater and surprised myself that I was able to wear a larger size than usual. Proof that I was putting on weight. I remember how sore my breasts were as I pulled my clothes on and off in the dressing room. Damn! I wished I would start my period.

Before he and I went out that night, still in Chicago, I asked him to lie down with me for a while. I was feeling really tired and sleepy—all the excitement, the shopping, and meetings. We lay down and talked about his job applications at other universities. We talked about whether I would consider moving with him if he got a job somewhere else. It was a very intimate moment as I realized that, yes, I would go.

Days earlier, I had bled while using one of those contraceptive sponges, and I was afraid that the plastic that held it together had somehow cut me inside. I went to the doctor, but he didn't see anything unusual, and there was no more bleeding. I was getting tired of going to the doctor. A couple of weeks earlier, I had been to Texas, to visit my ex-husband. He and I were having trouble negotiating the nature of our relationship until we applied for our marriage annulment with the Catholic Church. While I was there seeing him, I came down with a terribly uncomfortable yeast infection. He took me to a clinic, where they did a pregnancy test on me before prescribing medication. The doctor said it was routine. I remember looking at the white slide on which the doctor placed the urine specimen. It stayed white, and the doctor said, "You're not pregnant." Then he gave me a strong prescription for antibiotics because I had a urinary tract infection as well as the yeast infection, for which I was to use a cream. When we were leaving the clinic, I noticed the slide had turned blue. I asked if that meant anything. "No, no … don't worry. It's been too long. You're not pregnant."

The last days of November, I had bought a pregnancy test, and I was supposed to use it first thing in the morning, with the "first morning's urine." It came with this little bottle that you were supposed to fill with your urine, and the stuff at the bottom (that looked like coagulated old blood) somehow mixed up with it. Then you were to wait. I don't remember how long he and I timed it, but when I went and looked at it, there was a bright ring around the bottle. It meant I was pregnant. I picked up the bottle and took it to him, where he was sitting, still wrapped up in the white sheets on the bed. I remember feeling only a little numb, waiting for his reaction. "Oh, God," he said, the blood draining from his face. He didn't want the baby. He said nothing else. I'd been brought up to do what "he" wanted, so, without a thought, I gave up. In retrospect, I realize my habitual "obedience" and fear prevented me from engaging in any dialogue. I had no voice.

I really don't remember anything I thought. I don't remember making the doctor's appointment. But I remember the HMO physician confirming, "Yes,

you're pregnant." I told him I felt really hungry. He asked me if I was going to keep it or terminate. I said, "Terminate." The entire interaction felt surreal and, as if I were following a foreign script, I told him I was really tired. He signed a form and told me where I would go. The HMO covered the expense completely. I left. Something felt wrong. But I was on autopilot.

I visited the abortion clinic, and he waited for me in the reception room. I had not told anyone except him about the pregnancy. I filled out some paperwork and was taken to a room where a woman talked to me for a while. I do not remember a thing she said. Sometime later, I talked to my friend Steve, in Texas, and he told me that his wife was pregnant. I told him, "Surprise, so am I." Steve was overjoyed and could not understand why I was going to have an abortion. I said something about how "I just couldn't" or something like that. I couldn't bring myself to tell him that it was because he didn't want the baby. I felt ashamed.

When it was my turn to "terminate," they told me to go to the bathroom first. I noticed that I was bleeding a little when I went in, and my first thought was that there could be something wrong with the baby. I was worried. So I told the nurse, "I'm spotting." I wanted her to tell me what I needed to do to take care of the baby. She said, "Oh, that's normal." And then she told me to go and take off my clothes and put on this gown they gave me, and they would call me when the doctor was ready.

I didn't know at the time that I suffered from posttraumatic stress disorder and that, when triggered, I would become somewhat disassociative. I wouldn't know that for many years until I began therapy for recovery from my childhood sexual abuse. I didn't even really think much about those men and what had happened to me when I was a little girl. I didn't know that the reason I couldn't talk, that the reason I was not really "in my body," that I felt like I was watching everything I was doing, was because I was in a disassociative trance. All I knew was that he didn't want the baby, so I had to get rid of "it." And I didn't feel anything. But I was worried that I was spotting.

The doctor called me in, and a nurse walked me to a table and helped me onto it. They strapped an IV to my arm and had me put my feet into stirrups. I remember the doctor chanting or singing or something. I remember as they stuck the needle into my arm and, as they did, wanting to scream, "NO!" But it was too quick. I don't remember what happened next.

The sound of my own screams woke me, and I was lying on my side, with an incredible pain in my womb.

"Be quiet," the nurse scolded me.

"But it hurts …," I responded.

"It's supposed to. It's the medicine we gave you."

I continued to moan and groan loudly. I sobbed. My baby. My baby. What did I do to my baby? My baby. My baby. I must have been screaming out loud, because the nurse told me to shut up.

"You're going to upset the other women!" I looked around and noticed that there were several other beds in the room, and that there were women lying there, expressionless, not saying a word, as I screamed and cried. The physical pain was nothing in comparison to the searing knife that was stuck in my heart. I had killed my baby.

"I didn't know what I was doing!" I screamed.

The nurse yelled back at me, "Be quiet. You were given counseling." I remembered the little room and the five minutes I had spent with someone when I'd come in to fill out the paperwork. Counseling.

"That was not counseling. That was covering your ass!" I shouted back. "I had no idea what I was doing! I killed my baby!"

"Be quiet, or we will have to give you something to shut you up!" the nurse responded.

I clutched at my empty womb, its contractions reminding me with each horrible pain, that I had done what I had never wanted to do. I sobbed silently, wanting my crying to somehow take me somewhere where the pain in my heart would stop. A woman on a bed across the room spoke up.

"Thank you for what you said. They needed to hear that."

He came and picked me up. I don't remember dressing.

Two weeks later he asked me to marry him when we were visiting his family. He wanted to announce our engagement when we had Christmas dinner. I said yes ... but I changed my mind. If I'd known he wanted to marry me ... if we were going to be married ... the baby ... our baby At this point I know I had left my body and my ability to be fully in a relationship for a long, long time. I couldn't trust myself.

What *happened?* I see now that everything depended on what "he" wanted me to do. My will was secondary. Somehow I had learned that.

It is hard for me, much less others who know me to be a very outspoken woman, to understand or even believe that I could so easily do something that I did not want to do. That it was hard for me to express what I wanted. That I allowed myself to be so totally dominated by my perceptions of what the man in my life wanted me to do. Only years later did I come to understand why, throughout my adolescence and adult life, I seemed to go "blank" when faced with a male who wanted something of me in a sexualized context. Why my mouth wouldn't move to say "no" when my body was frozen and I felt close to nausea from the hands on my body or mouth on my lips. Nor could these men understand why I was so silent and reticent, like "talking to a glass of water," one boyfriend once told me,

when we talked about what I wanted or needed in our relationship. After all, I was Cristina … the outspoken one. The public speaker.

I think about *La Llorona*, and her wailing in the night after killing her own children. I think I understand. All that pain and fear gets silenced out of obedience to patriarchal abuse, whether it be sexual abuse like mine or the silencing that happens in an institution that only legitimizes the male voice. It distorts the female voice by creating a matriarch who smiles while a knife is embedded in her flaming heart. While we learn to try to maintain the silent pained smile, the reality of the pain and fear grows inside, until the Spirit of Truth in each of us can no longer hold back. There is no way we can heal with all of that pain inside. No way we can face the truth while our cultural voices are in a conspiracy of silence against us. So *La Llorona* screams.

La Llorona is me. All those times I have frightened people with my screams—perhaps not always literally—but the inner pain of my past silencings has moved me to say things in ways that are really hard for people to hear. All the times that I was more concerned about my need to "get it out" than noticing if people were ready to hear it or whether there might not have been a better way to make them listen. My pain made it hard for others to hear my voice.

But *La Llorona*'s power is hidden from us by focusing on the fear. Making us want to stay away from wherever she might show up, reminding us with her screams that we all bear secret suffering. That voice of hers is power—terrifying, dark, and beautiful power. We can ignore her and turn her into fairy tales or stories told around a campfire to scare each other. We can fail to see her when we ignore those around us who voice their pain in a way that makes *us* hurt. Or we can hear her in those voices, and realize that she brings us a great gift. She tells us about the deep wounds we have suffered at our own hands. She brings us the awareness of our humanity and how easy it is to be spurned by others. The voice of *La Llorona* is the "screaming voice of the Spirit, telling us how to heal" (González, 1998).

Prayer to Our Lady of the Sacred Heart

I come to you, with my eyes focused on your heart, Oh Lady, and I want so much to understand how you manage to keep that serene look while your heart is on fire and wounded. Is there some secret to it that keeps you from being a victim?

My prayer is that somehow you might be able to help me understand the difference between carrying my life's wounds with honor and dignity, and keeping them alive in a way that hurts me *and* those around me. Your image teaches me to believe there is beauty in suffering; please help me to know how this message can be something healthy. I want to express the truth about my life in a way that is honest and open. Guide me not to distort my life story either to make it prettier or to gather unnatural attention. Provide me the comfort that I will need when the pain of the wounds in my heart reminds me of what I have lived. And when pain results in growth, help me not to deny or minimize the real costs of that pain. And can I do this without becoming a martyr? I would love for my life to mean more for what I do while I am alive and joyful than for what I have suffered. Is that possible with you?

Can you show me how to be a woman who can stay alive and open to the thorns, while I celebrate and appreciate the beauty and fragrance of the roses on my life's path? Can you help me remember not to deny the painful realities of life in naïve efforts to be holy, good, or right?

I need to be refreshed often … please help me find the roses around my suffering heart and to smell the blessed fragrance from those same roses when I find my heart pierced by their hidden thorns. May your image appear before my mind's eye to remind me of these prayers when I find myself unable to ignore the intensity of the pain of the wounds in my heart. Help me understand … must I lose my voice in the process of loving?

Amen.

5

Journey of the Mind

Meeting Sor Juana

It's funny. I never heard about Sor Juana when I was growing up. Sor Juana Inés de la Cruz, or roughly translated, "Sister Joan Agnes of the Cross." I would have remembered that name. But she is someone who I really relate to now that I know a little about her.

I'd seen her picture since I was a little girl—she was on Mexican money and painted on historical murals found throughout Mexico. I had never taken the time to read the bills, never taken time to really listen when I'd heard the tour guides explain who the images on the murals were. To me, she was just a nun whose picture was on the twenty peso bill. Yes, it was impressive that a woman was on the currency, but other than that, I had no curiosity. My gut feeling was that she was some "holy" person, yet another saintly woman held up for us to be like. I was wrong.

You see, what I learned was that Sor Juana was a beautiful heiress (sounds like a fairy tale—aren't they *all* rich and beautiful?) who became a nun because she wanted to study. My skin bristles a bit even when I type that—it sounds a little too much like my way of thinking. After all, my whole life I've lived with the feeling that were it not for the religious constraints on being a nun, the lifestyle would have been right up my alley. All that time to study, to contemplate, to work in teaching, to pray, to live in community, and even travel! In my core, I sense that, if I had lived back in the 1600s when Sor Juana was alive, I probably would have wanted to be a nun, too.

Well, anyway, Sor Juana became a nun, but not just your run-of-the-mill nun. She was the rich women's nun. She provided spiritual direction to the wealthy, and she not only met with them frequently, she also did so as a sort of feminist

leader of the women. She wrote poetry decrying "those men," those oppressors of women in so many ways. And she wrote many *redondillas,* four-verse poems of love and jest, that made her all the rave among the elite circles. That's what I've heard, anyway. But she got in trouble for it, of course.

A bishop of sorts wrote her a letter, playing sardonically with her avocation for literary jousting, and did so under the pen name of *Sor Filotea.* You could say it meant Sister Lover of God. The letter invited Sor Juana to refrain from her writing and critiqued her. This is when Sor Juana took up her quill and responded from the core of her being. She wrote the now famous *Respuesta a Sor Filotea,* the "Response to Sor Filotea," in which she told of her life story. And in this life story, she told all that she had gone through, the way women were treated, critiquing society and religion both implicitly and explicitly in masterful form. In a way, Sor Juana, the nun with "a library of 4,000 books," is my historical heroine and, her respuesta, my model for this work. Except for one thing—after she wrote this piece of genius, she never wrote again. She's hailed as a heroine for all Mexican women, a nun who expressed herself. But this silence is rarely referenced in those accolades. So I had to write her, too. Because she's a little too much like me.

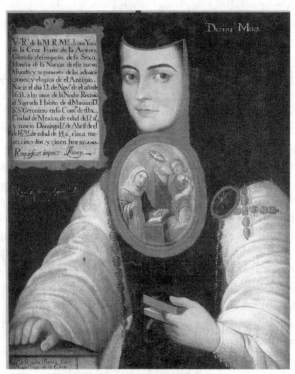

Sor Juana Inés de la Cruz

Letter to Sor Juana Inés de La Cruz

Sor Juana,

I begin this letter to you with great trepidation. My heart is frightened of the openness that honest expression to you requires. For you, Sor Juana, more than any other woman that has been placed before me in my lifetime, speak to me of my life's choices.

I was born centuries after you, *una mestiza,* and far away from the heart of Mexico, but carrying that heart within me—that heart, with all its chambers and echoes of the past, each beat a reminder of the walls and boundaries around me, telling me who I am, who I have been, who I should be, who I cannot be, and what I can and cannot say.

When I first learned of you, I found you so easy to comprehend. "Why, of course she chose to become a nun—it was the only way that she could study and read and write in the ways she felt called," I defended you. I could understand you in that way, my beloved sister, because I, too, am called by the yearnings to study, to express, to feel the passion and ecstasy of understanding. It seems so few around me understand just how deeply this passion runs in my veins.

You gave up marriage and companionship for the privilege of study. You did so knowingly, while it appears in my life that I did so without knowing that I was doing so. Twenty-five years ago I left home to study, and I have never returned to any place as home. My relationships have been stepping-stones on my path back to study, and my heartaches are far too familiar. Did you feel that way? There is loneliness in study—no one can go there with us to those private chambers of insight. But I think we crave to share what we are blessed with when we study—isn't that why we write? Isn't that what leads me to speak, to perform, to teach?

When I pray to my God, I can be honest about all that I am learning on my life's path. Did you find it that way, too? But when I try to share these things, I find that life is too full of rules and barriers, boundaries and propriety, egos and images … it is so hard to be honest in social expression. People will do so much to keep my words in synch with their minds, their expectations and containers. If only it did not hurt so much to have the people I love grimace at my heart's expression. How did it feel, Sor Juana, when you were confronted by the Church? Did it feel rebellious to you when you wrote your "respuesta"? You were so open about your life. Then for the years to follow, you were so silent. Did they get to you, Sor Juana? How did you express what you felt when you were silent?

It is hard for me to understand how we call the Church our Mother. It makes it hard for me to understand the Divine Mother. I left "Holy Mother Church" because I could not bear the walls that closed in on my heart and mind each time I spoke from my honest experience of God and life. And when I learned that my

ancestors were not only Indian, but also Jewish, the truth of history was just too much to bear. It is a painful step, to leave … but the silent pain of an institutionally veiled soul was far worse. Did you know the Mother in a way different from me? Was She comforting? Do you know if the Church truly *is* our Mother? I don't feel it. Did you?

Sor Juana, your work lives on to this day, and you are used as an exemplar of how we can find our way to expression as women, making choices against society's norms to insist on our right of expression. Did you know that those little *redondillas,* those little four-lined verses you wrote in play and jest, would become such classics—used as symbols of the strength of a woman finding expression within a repressive society?

While these things are true, I am afraid that I must point out that those final years of your life … with no more writing, with no more public expression—to me, they speak of what is all too familiar with this Church I once called home. To be part of the flock, we must be periodically shorn of our wool.

You see, I know what it feels like to be known for my expression, while all the while aware of what I am *not* expressing because of authority's control of my voice. Yes, even the rebel voice, the voice of the reformer, the voice of the change agent, held in check.

In your day, the Church had far more power over our physical lives—is it possible your words could have had you flogged or punished somehow in a way that would have left you destitute, socially abandoned, poor, or dead? We, today, are left that way in a much more symbolic and internal fashion, if we continue to believe in the ultimate authority of the Church. Better to be silent and faithful than no longer part of the flock … is that what your last years meant? Your life ultimately demonstrated the effectiveness of the Church to silence even the most vibrant and creative of voices. It is only in retrospect that we find the empowering aspects. I think it is important, Sor Juana, that we not forget that it is very likely that your life was a battle lost to the Church. I would like to think that in your silence you found great comfort, but I wonder. I doubt.

I mean you no disrespect, Sor Juana, and, in fact, I think that if I have come to know you, as you were, that you fully understand me now. God in all his and her power wants us to express the divinity that we find in life. Time has brought us answers to the prayers I imagine you praying as you prayed morning, afternoon and evening with your community. Divinity is not clothed in scarlet cardinal red or decorated with gold acquired at the expense of human life and civilization. And silence is divine when we enter into it for such purpose—not when it is imposed upon us.

I walk forward in my life now, Sor Juana, clothed not in the robes of a nun, or the vestments of institutional virtue, but in the beautiful veils of Spirit which glow

and sparkle and nurture me in all conditions … but which will never make me fit in. If there is anything that I learn from you, Sor Juana, it is that to affiliate my spirit with any institution, to make it servant to any structure, is to bind it and gag it. Family, marriage, culture, education, religion, gender, or race … nothing can hold spirit captive. I thank you for your prayers, as they are answered in my life. I beseech you to keep praying … for it is not easy. It is very lonely at times. I'm sure you know.

<div align="center"><i>Sor María Cristina</i></div>

My Protector—My Papa M. R.

His name was Manuel Ramírez González, and we called him Papa M. R. He was a rancher, a businessman, a political organizer, a farmer, philanthropist and devotee of *La Milagrosa*, the image of Mary before which he knelt three times a day to pray the rosary. My Papa M. R., my grandfather, used to sing a song to me when I was a little girl, "*María Cristina me quiere gobernar* …." I loved the attention, the way his eyes would twinkle when he smiled at me as he shuffled his feet when he walked. Papa M. R. made me feel special every time I saw him. And he taught me lessons that would see me through many a dark time in my life.

One of those lessons I have had to learn repeatedly—that to deny my truth would cause me harm. Papa M. R. was a man who was nearly murdered for always speaking his truth. He organized the local League of United Latin American Citizens (L.U.L.A.C.) in the 1940s to work with him to get the public high school in our hometown of Fort Stockton, Texas, to admit students who were of Mexican ancestry. In 1943, a law had been passed that no person of Latin American descent could "swim, drink, or look at the water" in the local Comanche Springs. Papa M. R. told me that he had taken my grandmother, Carmelita, when she was pregnant with my uncle Oscar (that would have likely made it in early 1947) to deliberately and defiantly look at the water. When one of the Anglo men who came to tell them to leave touched my grandmother, Papa M. R. told me that he vowed to have the laws overturned and that none of his children would be denied the education he never got. He told me there was no way to make it in the United States without an education. Of course, Papa M. R. was the exception. He had only two years of schooling as a young boy, and he had managed to survive through the great depression—a businessman who owned his own house, a ranch, and several businesses. Papa M. R. made me believe anything was possible, that no evil could *not* be overturned. He made me believe that education was priceless.

Papa M. R. died while I was working on my Ph.D. He was very proud of me for going to college and getting a master's degree and for working to be the first one in the family to be called "Dr. González." He was proud that I was working as

a project director for the Governor of Texas. He was proud that I had the courage to divorce my husband who had hit me. When I divorced, my grandmother Mama Carmelita took away the ring she had given me when I got married. It was the

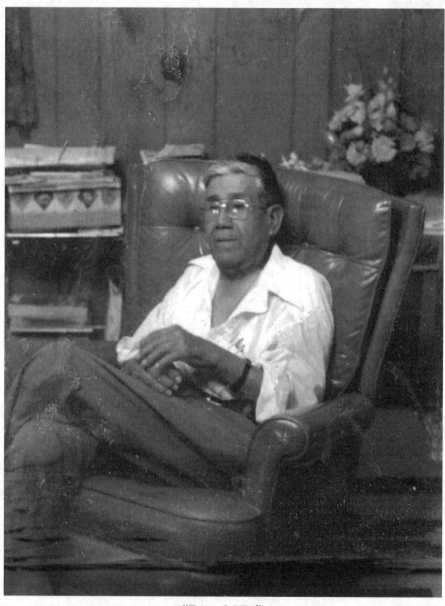

"Papa M.R."
Manuel R. González

wedding band of my great-grandmother María Cristina, for whom I had been named. Papa M. R. laughed and patted me on the knee when I told him about the divorce. Mama Carmelita said that Papa M. R. never got along with my great-grandmother.

When I was about three or four years old, I had asked Papa M. R. a question. We were at his house, the turquoise-painted house on Young Street, across the street from Butz School, the unaccredited school where the Mexican and Mexican-American children were sent to school and where segregation kept them until around 1970—when the law finally desegregated the elementary schools in Fort Stockton. Butz School was built on a cemetery—one that I remember hearing adults speculate was the cemetery for the Buffalo soldiers who were stationed at Fort Stockton to keep the Apaches from reclaiming their homeland near the springs. Of course, the Indians and the African Americans whose bodies lay beneath our homes and businesses and roads in Fort Stockton were rarely acknowledged—are rarely acknowledged to this day. Whenever I speak of them when I am home, it is as if I am telling fairy tales no one cares to hear. But Papa M. R. taught me to treasure the stories—the true stories.

When we were at his house that day, I asked him if he would tell me why women have to get false teeth when they are old, but men didn't. My grandmothers, both in their 50s, both had false teeth. My grandfathers, of about the same age, did not. What I now realize is that both my grandmothers grew up in abject poverty. Mama Carmelita was born during the Porfiriato preceding the Mexican Revolution of 1910 and lived through the years when her hometowns in Mexico would become the sites of revolutionary drama. Mama Fina, my mother's mother, was born to an Apache woman, along with seven brothers and sisters, in the small village of Boquillas del Carmen, on the banks of the Rio Grande, across from the area that is now Big Bend National Park in southwest Texas. In 1906, she and her siblings crossed the river in a small boat with their mother, Petra, and somehow traveled the 150 miles to Fort Stockton across the dusty desert roads. My grandmothers had false teeth because they had not known of dentists or the luxury of dental care throughout their lives. My grandfathers, both third-generation citizens of Fort Stockton, came from two families that had not wanted for food as children. Both of my grandfathers were breastfed and weaned by my great-grandmother Petra González, a woman of Rarámuri ancestry from Chihuahua, Mexico, who had married my great-grandfather Isidoro. My Papa Cosme, my mother's father whose father was Basque and mother was of Sephardic ancestry, was orphaned when he was six months old after his father had been murdered by an Anglo storeowner, and his mother died from illness. The family's land was stolen in a land-swindling enterprise organized by a small group of Anglo men who would falsely witness the "X's" standing for the signatures of Mexican landowners. Both

my Basque and Sephardic ancestors—the Uruetas and the Garzas—had major plots of land in what had been Nueva Viscayna, now Texas, the territory named after the Tejas Indians who were known for their friendliness. Both the Uruetas and Garzas were literate and well-off. The Garzas were Sephardic herders who came to Texas from Monterrey, in Mexico, many arriving in the San Antonio area. My great-grandmother Honorata Garza came to our hometown from San Antonio. The Uruetas from Chihuahua, bore Jesus Urueta, one of Mexico's greatest orators and father of the famed Mexican woman artist Cordelia Urueta. My great-grandfather Rosario Urueta was a county commissioner. He knew how to write his name. There was no need to sign a deed with an "X" or to have a witness.

When Papa Cosme married my Mama Fina, they wound up living with their seven children in one room of the Catholic school by St. Joseph's Church during the depression. The school had been built on the plot of land on which his grandfather Pedro had built his house in 1867. Papa M. R. kept a grocery store going that helped the Mexicans buy their food during the depression—he finally had to close it down when there was no way to keep giving them credit, but he kept many from being deported.

These are the stories I heard growing up.

When I asked Papa M. R. about the false teeth, he laughed. He said that wasn't true. I disagreed—told him that it was! I was using a little girl's scientific method of observation and deduction. If both my grandmothers had false teeth, and both my grandfathers didn't, then it must mean that women had bad teeth. After all, I had all my front teeth capped and was told it was because I had bad teeth. (I later realized it was because of my severe earaches as a young child and the high doses of tetracycline I was given for the ear infections. But at that time, it all added up to the fact that females had "bad teeth.") It wasn't fair. I wanted to know *why*. Papa M. R. was amused.

He told me that it wasn't true—that *he* had bad teeth, too. And he demonstrated this for me, weakly moving his jaws together to show me how his teeth *"no tienen fuerza,"* did not have any strength. I looked more closely, skeptical.

Papa M. R. then took his finger and put it between his teeth and bit it. *"¿Vez? ni duele,"* he told me, assuring me that his teeth were so weak that he could not even hurt his own fingers when biting them. I still doubted. He asked me for my finger to prove it. I reached up with my little right hand index finger and he took it in his big brown hand, placing it between his teeth, and biting down firmly on it.

I screamed and jerked my finger away. It hurt! I looked at him incredulously. He smiled and said to me, *"Para que veas,"* that I might see ... *"no te crees ... porque duele."* He told me that I shouldn't believe things when I know they are not true, because ... it hurts. I learned my lesson.

Or so I thought.

You see, not all the truths that I began to believe and swallow up as my own were as obviously dubious as the frailty of Papa M. R.'s teeth. Papa M. R. had told me how good it was to go to school and get an education. And I loved school. I was good at it. I was better than everybody else, even! I didn't notice how the further along I went in school, the further I got from my history, the further I got from my grandparents and Fort Stockton. By the time I was in graduate school, I spent only a total of several weeks at home each year. I rarely spoke in Spanish, even though that is the language that erupts from my mouth when I am angry or tired or frightened. I spent most of my time with people who would ask me things like, "do you eat Mexican food every day?" or say things like "when I look at you when you talk, you have an accent." I went out on dates with men who seemed to fall in love with the fact that I was "exotic-looking," but who preferred me in English and soon forgot their courtship promises to learn Spanish once they had kissed me.

When I would travel home from college, I became more and more aware of the fact that I now had two lives—the one that formed me and created my personality and the one that I had learned to live through education. It was the latter life that I discovered society expected me to live.

Papa M. R. died while I was in Chicago, interviewing for a job as a professor. I had been with him only a few weeks earlier, while home for the Christmas holidays. He was suffering from a very large and uncomfortable hernia and was going to have surgery to repair it soon after I left. While on that visit, he and I talked for a very long time. He told me stories about how he worried about the family and how his sons had lost sight of what was important. He told me he was worried about my grandmother, Mama Carmelita—that he worried that no one would take care of her once he was gone. He asked me to always stay in touch with her—told me that I was her favorite, that I was very special to her. I told him I was going on my interview to Chicago, and he was proud.

When I left Papa M. R. at the house at the Rancho Grande that cold January night, he held my face between his hands and looked me deeply in the eyes. He kissed me on both cheeks, he kissed me on the forehead, and he kissed me lightly on the lips and smiled fondly at me with his twinkling eyes. In my heart of hearts, I knew that he was saying good-bye to me, for the last time. I walked outside to my car as Papa M. R. stood in the doorway waiting to see me off as he and Mama Carmelita had always done. The cold indigo night of the desert winter was crisp and silent as always, with the moonlight and stars bright silver. I waved as I got into my car and started the engine. He closed the door and I collapsed in tears on the steering wheel. I knew I would never see him alive again. As I drove my car down the dirt road away from the Rancho Grande, I knew Papa M. R. was kneeling in front of *La Milagrosa* for his night prayers, and I knew as he prayed that rosary that night, that he prayed for me.

When I was interviewing in Chicago, a call came from my mother to call home. I was given the message by one of the faculty members at the university where I was interviewing. I held my breath and felt Papa M. R.'s spirit pass through me.

"Aren't you going to call?" she asked me.

"Oh, I'll call later," I responded. "My grandfather just died." I flew out of Chicago the next morning for Texas, en route to Papa M. R.'s funeral. I sobbed throughout the funeral, somehow knowing in the depths of my soul the price of an education. Somehow knowing that Papa M. R. knew I knew.

Some might say to me, "We all have had to give up things because of our education." Actually, many people have said that to me. They have said that it's all part of what happens in families—that people move on and leave things behind. Somehow, I get the impression that when I tell my story they don't want to hear the depth of the pain that I am expressing. It's often been difficult for me to talk about this, because at some level I learned that to bring attention to my education was a way of bragging—that I should note do anything to make others feel as if they were lesser than I simply because they did not have a college education. I don't intend to say that I deserve any special accolades or sympathy for getting my education, but at another level, it can no longer be denied for the difficult and arduous spiritual path it has been. I have come to recognize that when we follow a passion, as I have followed the passion for learning and education that my Papa M. R. gave me as a child, that we sacrifice our lives for that passion. Chicana women with Ph.D.s truly are not many. We are few in the academy, fewer within our own people. If we hide our gifts in fear of inspiring envy we are adopting a false humility that silences us and prevents us from developing and offering a view of a wise, centered, and loving Chicana warrior-scholar-woman.

The *Oxford American Dictionary* says that when we sacrifice something, it is "the giving up of a valued thing for the sake of another that is more important or more worthy." I have struggled because I did not realize that I was sacrificing my family when I sought the education I was prepared for from the moment I became the first grandchild of M. R. González. When I talked with Papa M. R. that last evening in January of 1985, I believe he knew that it was the family that was being lost. I believe he knew that I alone could grasp with him the depth of the sacrifice we were making with our educations and "successes."

I am surrounded in my humble little rented home by my large personal library, and I am almost never without a book at my side. I keep pen and paper with me should I ever find the inspiration to write at some unexpected moment. I have committed to this journey of the mind in my life and to the wisdom that Papa M. R. knew would somehow come from it. He told me that education was the only way to stop discrimination. He wanted me to be able to do whatever I wanted

to do without ever having someone tell me I couldn't simply because of my ethnicity or skin color.

So now I teach about discrimination and prejudice, and I think I am doing the work this incarnate life was meant to have me do. And this journey of the mind has helped me to see what Papa M. R. saw so clearly that cold winter night with me … that, to get rid of the discrimination, we have to let go of our histories and families … and it hurts. But it must hurt more to believe it isn't so.

Thank you Papa M. R.

Gracias.

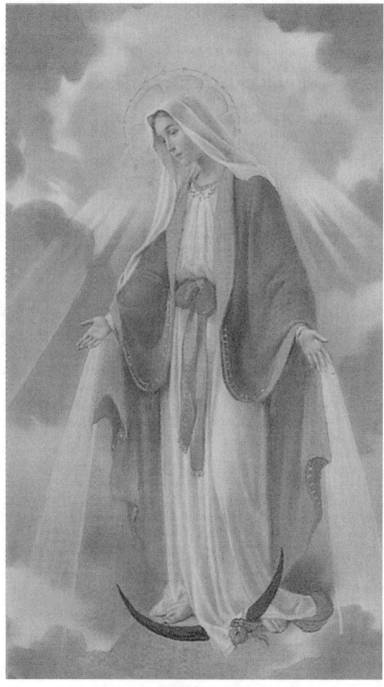

La Milagrosa

La Milagrosa

with light streaming from your hands
you promise to grant us miracles
and I remember
my grandfather
who believed in you
and whose life
was full
of miracles.

You, Lady
are making me wonder
if there isn't something I've been missing
on this educated journey of mine
if there isn't something missing
from my reverence of tradition
without noticing the
Faith.

It is a long distance
from the head to the heart
and I have laid the stones
of that long road
with passionate gusto
is there no way to join the two
no way to unite these two
sites of human passion
or must I forever be split.

Oh Miraculous lady
if somehow I found miracles happening
if I turned to you
would that change my life?
would I find the answer
to the many questions
long-eluding my mind?

Maybe
just maybe…
could it be worth a try?

Prayer to *La Milagrosa*

Dear Lady of Miracles,

To come to you is the greatest test of my faith, for I wonder if, in fact, I do believe in miracles. But I come to you as the emanation of the Divine One, the face of what is possible but stays beyond our reach because of our fears and learned limitations.

I want to ask for the greatest miracle of all, sweet Lady. I want to be freed of the traps of my mind. If there is some way that all I have learned can be used only for good, and that nothing that has entered my mind ever be allowed to keep me from You and all that is good and beautiful and true, please let it be so.

There are so many sacred boundaries I have erected around my soul. So many sacred boundaries I have adopted out of obedience and fear of authority and fire. I see the symbols in your image and believe that the light, which shines from your hands, can bring both the loving kindness and discerning strength I need to keep evil from dominating my life.

Please free me from everything but a pure faith in what I am here to be. Protect me from my self and from the games of the intellect, from the fears of the heart, and the schemes of society.

If you can grant me these things, O Lady, then you are in fact the miraculous One, who can hear in my prayer the hope that can lead to faith in nothing but Love. I want to believe without effort. Only a miracle could bring this. So I ask you for this, and for the strength and gifts to live the life I have prayed for.

Amen.

6

Journey of the Body

La Dolorosa

dark shadows loom
in candlelit corners
where no one dares speak
of the emptiness there
a barren cross
with blood stains
remains
the essence of memories
that never quite leave.

Here I find you, Mother
in my darkest hours
when the simple memory of light
burns deeply in my open wounds
here I find you, Mother
in the shadows
of a life's performance
where whispers suffice
to awaken my ghosts.

Indigo hues of a rumbling sky
the fragrant waters of a pregnant
womb
flooding the desert dirt of an earth
packed hard by the stubborn steps
of life's lingering woes.

I find you, blessed Mother
in moments of purple agony
when death is all I know of life
and pain is all I know of love
it is you, blessed Mother
from whom my tears forever flow
ablutions for my sullied soul
an ointment for the aching
of a past that will not heal.

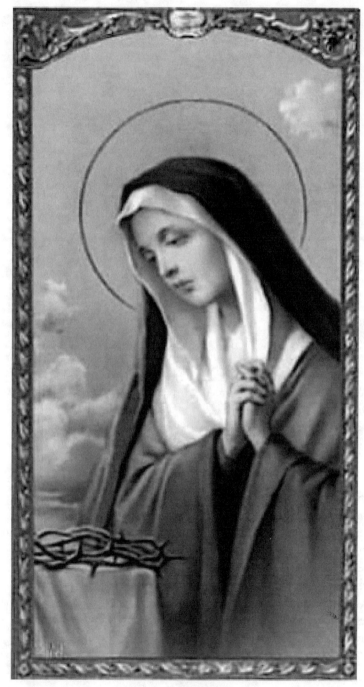

La Dolorosa

Unpacking the Mystique of Frida Kahlo

Frida Kahlo is such a well-known face and personality that she has become a stereotype. That's what I think. I didn't really know much about her growing up, but I found her images provocative and powerful when I discovered them in college. Still, I didn't take much time to get to know too much about her. I knew she was an artist, I knew she was a feminist, or at least acted like one. I knew she was married to the great muralist and painter, Diego Rivera, and that they were Communist. I knew that she represented a lot to a lot of people. But I didn't know much about *her*.

In the mid-1990s, I was fortunate to see a community theater piece in Phoenix, Arizona, about the life of Frida Kahlo. It was there that I learned that her father was German and Jewish, her mother from Oaxaca. I learned that she had become interested in revolution when a young woman, and that she had been madly in love with a young man who left her after an accident. This accident created great pain for her, and the play alluded to the idea that Frida committed suicide to end her life, never ceasing to love and adore Diego Rivera, the womanizing husband to whom she always returned. I was in a relationship to a man who psychologically terrorized me at the time, and he used to say, "Ay, Frida!" when I would be exceptionally Chicana ... he said I reminded him of her. It pissed me off. I resented her because she stayed with Diego Rivera in the same way that I stayed with a man until we were foolishly married. I lost the baby we conceived, suffering intense emotional abuse because I did not know how to escape my life's scripts for being with a man. Whose fault is it when the trail leading to the door is so convoluted?

It was not until I lived in Mexico in 1998 that I let myself delve more deeply into the woman, Frida. Because Mexican women are not seeking an identity in the same way as we Chicanas, they also praised Frida, but they didn't seem to have the same sort of *need* for her. As a result, the descriptions of her life seemed more balanced, less glorified. And the books I read in Spanish were similarly multifaceted.

It seems Frida used to love to say that she was born on the eve of the Mexican Revolution in 1910, but that there is no proof of this. I saw several sources while in Mexico that provided contradictory birth dates for her. She was a rebel at heart, but one with an incredibly *soft* heart. I learned that she wept easily and that she was known for breaking into tears at the slightest provocation throughout her life. That's not an image I'd ever learned about.

Her accident in a mass transit vehicle in Mexico City while traveling with her boyfriend, Alejandro (my father's name), left her so critically injured that she spent months in bed, shards of metal ripping through her womb and leaving her uterus scarred so severely that she was never able to bear a child. This is where all those

images of fetuses and wombs in her paintings come from. When she was bedridden with her injuries, her mother bought a huge mirror and hung it above her bed, so that Frida saw her own pained image during every open-eyed waking moment. They say that this is the reason she painted herself so much. She painted what she knew. Nothing more, nothing less. When she felt pain, she saw her own face and could not escape it.

Frida didn't like it when the artists of her time referred to her as a surrealist, or even that they considered her an artist. She painted because she had to paint, to express her pain. It was not an effort to create images for others—it was about painting what she lived. Diego Rivera recognized her genius, and she found something in him, in his own genius, that comforted her, after being heartbroken when Alejandro left her following the long recovery from the accident.

One story that particularly struck me was about her eyebrows. Anyone who's ever seen Frida's self-portraits would be familiar with the thick black eyebrows that meet menacingly in a peak between her eyes. I remember when I saw the play in Phoenix, that the young woman who played Frida had actually put on stage makeup to mimic these thick eyebrows. But when I saw photographs of Frida, and especially a couple of them in which my Chicano partner said he saw a resemblance to me, I could not find those eyebrows. They weren't there. Frida painted the eyebrows in the shape of a flying black bird, they say, because of her desire to fly away from her prisons. I wonder how many other aspects of her surreal realism had other hidden, deeply personal meanings for her. Probably too many to count.

I heard that the house in which she and Diego Rivera lived in Coyoacán, a colonia in Mexico City, the *Casa Azul,* the blue house, was the site for many neighborhood parties and gatherings of artists when she lived there. One of my older graduate students grew up as a child in that neighborhood, when Frida was still alive. She says she remembers Frida was a rather everyday kind of person who lived there with everyone else. Yes, it was the common nature of the lives she and Diego lived at heart that made them so appealing to the Mexican people. They were Mexican. The image I learned about in the United States was about a sort of glorified Mexican like the Frida that everyone wanted to see when she was invited to New York or Paris to be on display in her indigenous clothing. The Frida I got to know in Mexico was happy to be a Communist, wearing pants, weeping readily when she hurt, and hidden behind her façade.

Among Chicanas, I have heard of Frida as "the first Chicana" because of her borderlands identity, her rebellious nature, the brazen nature of her art, and her freedom in love with both men and women. But in Mexico, I found women who related to her because she was a Mexican woman, who lived with her pain at all times—physical pain, emotional pain, cultural pain, gendered pain. And this is the Frida that invited me into the journey of embodied bitterness.

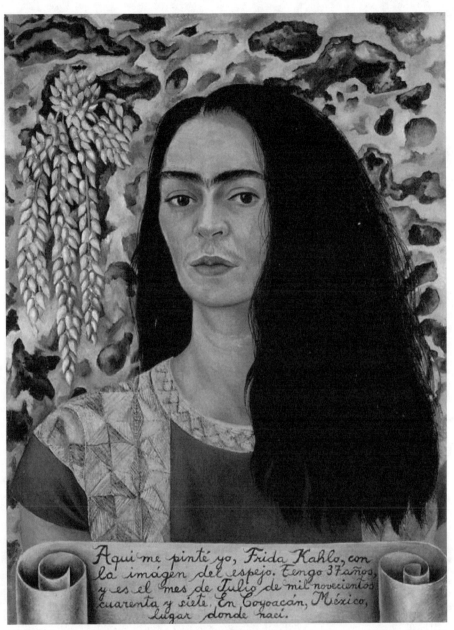

Frida Kahlo

Letter to Frida Kahlo

Querida Frida,

¿Qué te puedo decir? What can I say to you? I wrote you once before. I was very angry. Full of resentment. Blaming you. Blaming you for creating the possibility of what I was experiencing. *Ahora,* I write to you after coming to know you a little better. But I don't know what to say.

Yo no he sufrido lo que tu pasaste. But that is what still seems to make me so mad, I think. I hate being silenced by the awareness that I have not walked in your shoes. Being born to a father who became wealthy in my adolescence and who was politically powerful has often cursed me to be told by my fellow Chicanas that I am not "really" Chicana. What the hell does *that* mean? That we're defined by our socioeconomic status?

I see things in the way you lived that remind me of myself. Your success came from your suffering. The way you denied that you wanted to be known as a famous painter, but the way you used it to fulfill your dreams of travel. The way you said you didn't care about convention, but were obsessed with Alejandro when he abandoned you. The way you returned to Diego again and again. I resent you, Frida Kahlo, because I am so much like you. Having to eat out of the hand of the *enemigo.* Having to reach into the depths of my own suffering and psyche to produce the work that calls people to me. Frida, you remind me that I am not in control, that in fact I have trouble finding a sense of my own agency, even when perceived as powerful.

I know what it is to love a man who is not faithful, whose eyes cannot be kept from roaming, and who lies to me. I know what it is to live with daily physical pain from an accident. Mine was not nearly as bad as yours, but then, Frida, it is all in the way we use that pain, isn't it? And how can we use it if we do not keep it alive? Healing changes it. Frida, you remind me that sometimes I want to keep on suffering, that I fall in love with my own pain.

Ay, Frida. I remember when someone told me that I looked like one of your photographs. It was the eyes. I knew what he meant when he called me *Frida.* My beauty for him was coming out of my poignant state of being. Like your decorated presence in New York, dressing just like an image of what a Mexican woman should look like. Keeping them happy in Detroit or Paris. Even what we want to wear becomes something that is for them, *¿no es cierto, Frida?* There is no way to hide who we are. We might as well surrender to it. *Los ojos* … the eyes … no matter what we do to hide, those eyes tell the truth.

Who would you have been, Frida, if you had been able to choose? Would you have married your first love? Would you have avoided that tragic accident that left you crippled? Would you have given up your painting in favor of the freedom to

move about? Would you have had the children you lost? I somehow do not think so. Maybe because I have learned that regret is all about wanting a lie. Your paintings were as glaring and honest as our lives are when they come to us each day. You didn't paint a portrait of an image. You painted the experience itself. And they dared to call it surreal. No wonder you protested. We cannot deny the things that make us who we are, can we?

I love the way you had yourself carted into your last exhibition. On your hospital bed, so near to death. As much as I resent the ways in which I am like you, Frida, I want to be more like you. *¡Que me valga madre!* If I make them uncomfortable, *¡que me valga madre!* If it will only make it more difficult for me, *¡que me valga madre!* If it is considered rude or impolite to be who I am, *¡que me valga madre!* If my work seems too intimate, too brazen, too naked, *¡que me valga madre!*

Ay, Frida … Some would say I am already like that. Am I? I feel so much fear sometimes when I venture out. *No lo ven. No me ven.* People don't see that. I am in much pain so often, lonely in my little place in this world. Frida, did you feel this? *Se me hace que si* … Could it be that your courage was that you acted in spite of the fear? That you kept on in spite of the loneliness?

Dicen algunos que te suicidaste. If it is true that you invited death as you approached your last day, I only know that I cannot judge you. But Frida, I hope it is not true. Because I do not want a death from which I can not return.

Frida, *¿qué pasó? ¿Qué me puedes decir? Dime, Frida. Por favor. Dime.* Did you ever learn how to avoid eternal death?

Cristina

Discovering the Bitterness in María

I am María
enamored of the bitterness
of the narrow places and spaces
where I have lived and been
where I have found my God
—in secret.

T'shuvah
the invitation to turn
to repent
how can I turn
María
lover of the dark night
with the pomegranate heart?

—how to turn and leave
the so familiar exile
the so familiar servitude
bitter herbs signaling
the doors to secret hiding places
where I have met
my God.

I have identified with darkness
with desert dryness
and the terrors of the night
hands opening closet doors
that I might hide
again and again and again.

generations and generations of
practice
present Xicana life mirroring
centuries of history
souls bound in the narrow places
ancestors of many lands
heartbeats stifled
beneath the rubble
never quite sure
how to find the temple
in the here and now
in this present body—
me.

the recognition of a dance
the lifelong fears
the anger and anxieties
dancing in the darkness
with my ancestors
centuries of divinity
in secret corridors
Adonai, Eloheinu, Shekinah, Yah
Ometeotl, Tonantzin
Coatlicue, and Quetzal
I want to dance with you all
in wide open spaces.

"My name means ..." I remember learning that González probably meant "son of Gonzalo." There wasn't too much excitement to this discovery. Maybe back when Gonzalo was somebody everybody knew somewhere, maybe then it would make sense to be one of the sons of Gonzalo, ... but then I would be a *daughter* of Gonzalo, no? Nevertheless, I wanted to know—because knowing what your name means is a big deal. I've always sensed this.

My grandmother, Mama Carmelita, once told me that she was very glad that she had not been named for her mother, María Cristina. I, on the other hand, *had* been named for her. It was something that made me special, for although I had never met *"Cristinita"* as they all called her, I had never met anyone who didn't talk about her as if she were a saint or holy person. *Cristinita* was little, like me, with tiny little hands and feet, like me, they said. But when I got her wedding band when I was married, it was huge and was too big for any of the fingers on my hands except my thumb. It made me wonder what she was really like, this little woman I was named after, who had blue eyes so blue and skin so white that people thought she was a *gringa*.

Mama Carmelita told me that *María Cristina* was the name of a martyr, and that the reason she was glad she had not been named for her mother is that if you have the name of a martyr, you will suffer throughout your life, *"como mi madre, bendito sea dios."* Yeah, well I can see that. But was the suffering in my life that easy to explain? Because I had been given the name of a martyr? Later, I found out that Christina was sort of a generic name for Christian women, and that St. Christina was probably just the name given to represent all the women who were martyred as Christians. Wow.

I was named Maria Christina when I was born. No accent in Maria, and an "h" in Christina. After I spent a year teaching in Mexico in the late 1980s, I felt uncomfortable with the spelling. For one thing, if I had been named after my great-grandmother, she had not spelled it that way. And she had a Mexican, a *Spanish* name. My name had been anglicized. In 1992, I decided that I was going to change my name's spelling. I put in the accent in *María,* and I took out the "h" from *Cristina.* In Spanish, there is no such thing as Ch-ristina.

When talking with others about the effect of the Catholic Church on my personality, I often joked, "What would you expect? With a name like 'mother-of-God-follower-of-Christ'?" What a combination! If names are destiny, then certainly, my grandmother had had a point about mine. Who in the world could live up to a name like that? But is that what it really meant?

My teacher and friend, the late Spencer Bear Heels, a Lakota elder from Mission, South Dakota, on the Rosebud Reservation, gave me a name after I had spent several summers with his family and been "put up on the hill" for a *hanbleceya,* or "vision quest" by him. He told me my name was *Wacante Wiya.* I remember talking with him about the name the last time I saw him. He was sitting in his pickup truck, outside his house. I was packing my truck, preparing for my drive back to Arizona. He called me over and asked if I knew exactly what the name really meant. I waited. "Woman. Woman with a heart. Woman with a heart, for others. That's you," he told me.

My Aztec day-name, according to one interpretation of the remaining codices not destroyed by the Spaniards, is *Ce Ehecatl* (Balthazar, 1993). It means "One Wind." Your day-name is determined by finding the day you were born on the Aztec calendar. There are hundreds of combinations of numbers and totem animal and plants, depending on the cycles of name rotations. *Ce Ehecatl* is the name that is supposedly given to someone who is to be a "remover of spells," and very possibly, a shapeshifter. I could make sense of that over the years by acknowledging my work in communication and as a bicultural Chicana who has had to learn to change my shape through language and behavior. My drive to look for the truth in situations and stories could certainly be a way of removing "spells," those dastardly distortions in interpretation that oppress us when we give them the power to tell us what is real.

But *María Cristina.* Cristina is pretty straightforward. Whether it is Cristina, Christina, Kristen, Christiane, Kirsten, or Kristine, it means "female follower of Christ." I had only assumed *María* meant "mother of God." After all, she was Mary, wasn't she? I read in a book once that the name María comes from Hebrew, from the root *maror,* meaning "bitter herb." *Bitter herb?* It would be a while before the power of this meaning would make itself known to me.

On my mother's side of the family, for as long as I can remember, my aunts would joke about how we "were Jewish," when trying to come to terms with the ways of the women in our family. We could even tell you which side of the family was Jewish: The Garzas. In fact, the Garzas were Jewish, and their history well documented as having fled Spain during the Spanish Inquisition. Some were even burned at the stake for daring to continue to practice Judaism after being forced to convert to Catholicism. Having honored my native American ancestors through years of spiritual practice, I thought it reasonable that I do the same to my *converso* ancestors, the Sephardim, Spanish Jews. In 1995, I began to secretly study Judaism, attending lectures by rabbis visiting from Israel, and arguing that the received view of Christianity seemed to leave out a lot about its appropriation of Judaism. I was moved by the idea that two sets of my ancestors had been victims of Rome.

In 1999, I decided to celebrate Passover when I was living in a room, alone, in Mexico. It was far from a kosher celebration, and the seder that I prepared for that first night of Passover was very naïve. But my heart was in it. I had a really hard time finding the right food. There was no matzah to be found, so I settled for some hard crackers, even though I knew that they probably had some baking soda in them. No Kosher wine, either, so I bought pure grape juice, enough for four glasses. I didn't know if I was supposed to have lamb or an egg, or how to do it, so I decided to trust that my intention would carry the ritual for me. The most significant part the celebration for me, however, was the "bitter herb." *María.* My name. I actually couldn't find any fresh herbs and, as sundown was approaching, I took two pieces of lime rind and decided they would have to do.

My understanding was that the bitter herb is supposed to remind us, through the bitter taste, of the experience of slavery in Egypt, which the Israelites had to suffer. The word for Egypt in Hebrew is *mitzrayim,* and it means a "narrow place." A narrow place in our everyday lives is anything that prevents us from experiencing spiritual liberation. The narrow place, the *mitzrayim,* is bitter. The bitter herb reminds us not only of the experience in Egypt, but also to look for those narrow places in our lives today that keep us in slavery. *María.*

A few days after Passover, I received an e-mail message from a dear friend who told me that he had detected some deep bitterness in me regarding the death of a friend who had been rather cruel to me while alive. Because of my Passover meditations, and my new awareness around the idea of "bitterness," his words sounded like a bell, calling me to look deeper at what I might be feeling. I found that indeed, bitterness had characterized my response to this friend. But it had also characterized my response to a long litany of people who had somehow betrayed me or lied about me over the years. I was bitter. Was this bitterness keeping me enslaved, in *mitzrayim?* And if so, enslaved to what?

The trip to the Promised Land required that the Israelites travel through the desert, and my response to this bitterness required that I make a choice. Was I willing to leave behind my pride regarding these women and men who had betrayed me over the years by lying, appropriating, or mocking me? Is it possible that by holding on to a belief in my "innocence" I was keeping myself enslaved and unable to move toward my liberation? Was I willing to face the desert where I would let go of my attachment to innocence (or a sense of moral superiority) and dare to see what Adonai, the Master with an unspeakable name and unfathomable face, would reveal to me from that burning place in my own heart?

I developed at an early age, the idea that I was a bad girl who had to act in a way to convince others I was *good*. Through silent meditation and personal journaling, I began to explore this narrow place. I let myself travel through a desert, where I was not protected by the slavery of having to look good. It did not feel good. But I came to realize that all these people who had betrayed me one way or the other had hurt me not really so much because of their betrayal, but because I was deathly afraid that the lies they told would be believed by others. And that somehow my "cover" of goodness would be blown. That people would *dis*-cover my very real badness.

This badness is the truth of the fall-redemption tradition in Christianity which teaches young children at a very impressionable age that they will be punished by God if they aren't good. Goodness is not something inherent; it is something you must act out—it is something you must *become*. So when horrible, abusive things happen to you, if the theology has done its work, it must mean that somehow you deserved it. Somehow, in my life, I figured out that if I could just *be* good enough *all the time,* then I could keep bad things from happening to me. I could keep God from noticing my badness, and I would not be punished. With life being what it is, such an institutional position will keep people perpetually in search of where they failed, in order to explain life's tribulations.

Every time I was betrayed by someone lying or misrepresenting me, the pain I felt was incredible. The fear that others would believe them and not listen to me, to my truth, my "but look—see, I'm not a bad person … see how good I am … please don't punish me!" was greater than any social betrayal. So I hung on to the bitterness, because it was a way to hang on to my innocence, a way to say, "I have no shadow! God, *they* are evil … I am good! Please, don't punish me!" My bitterness was rooted in Church doctrine, and perhaps that of my ancestors, who were forced to convert to such ideas.

My walk through the desert and the stories of the Jews in Egypt, the dryness and hunger of the desert, these all have new meaning to me today. I don't have to be a piously perfect person to meet God. Goodness is not about performance. It is about simply existing. In the Torah, when God finished creating the world, the

Genesis story tells us that at each step, he said it was "good." This original goodness (Easwaran, 1989) is far more powerful and true to me now than original *sin*.

I am no longer *María Cristina*. I do not have to identify any longer with the martyred *Cristina*. I can remember *María*, the Jewish woman who lived a Jewish life, as I claim my new identity with a name I chose myself to honor my decision to convert to the religion of my Sephardic ancestors: Sarah Amira. Sarah was a matriarch who did not smile in silence, but who laughed at God out of her humanity. And Amira, an anagram of María, is the Hebrew word for "saying," as in expressing the unwritten truths.

Today, I can remember the taste of the bitter herb that helped me to identify the *mitzrayim*, the narrow places, that keep me enslaved to ideas, persons, habits, or tradition, preventing me from seeing the truth. Yes, Mama Carmelita, I was given the name of a martyr. But I have discovered that in fact her name was not even María, it was Miriam ... another woman who dared to speak and act her mind and heart. With a few slight changes, María has become Amira ... she whose heart is able to speak to her mind and whose voice is not stifled, but expressed. María speaks through Amira.

Prayer to *La Dolorosa*

Oh blessed Mother, you bring me such consolation in my moments of deepest sorrow and anguish, but I ask you from the depths of this battered heart, to free me from the identification with your pain as a model for what I should be as a woman, that I might see you in all your glory and not only in your suffering. And somehow learn to see my own glory too.

Help me, oh Mother, to reject the temptation to be *sufrida* in your name, and to identify with the stories that keep me stuck in the narrow places. Help me not to accept inhumanity and injustice toward the dignity of women in your name. Help me, *mi madre,* to seek your consolation when I walk the dark paths, but to never hide behind your face to avoid confronting those who would keep us in that darkness.

Help me to remember that your eyes were motivated by love and that my eyes should also look to the freedom from all oppression and bondage.

7

Journey of the Voice

La Malinche … La Malinalli

The first time I remember seriously considering *"La Malinche,"* I was living in Chihuahua, Mexico, in 1988. President Salinas de Gortari had just been inaugurated, and he was promising the people a time of great *modernidad y solidaridad,* modernity and solidarity. The election had been controversial—there were claims that the *Partido Revolucionario de Independencia* (PRI), the dominant political party in Mexico, had interfered with the vote counts in several important voting regions. The economy was in a flux, and people had not recovered from the huge crash of the peso several years earlier. There was a move to bring in the *maquiladoras,* the foreign assembly plants, that promised great economic renewal and cultural transformation to the nation. It was this setting that enabled me to hear Mexicans referring to other Mexicans as *malinchistas,* or people who acted in the fashion of *La Malinche*—the legendary historical consort of Hernán Cortés, the famous Spanish conquistador. A Mexican who shows preference to things not-Mexican, to foreigners, and ways of other cultures, is a *malinchista.* It is not a compliment.

Her real name was not Malinche. It seems that this is a hispanicization of the term *malintzin,* the name given to Cortés himself, for being the lover of Malinalli. Malinalli was her real name. Even the fact that her name has been bastardized speaks to the nature of her significance.

The historical legend goes like this: Malinalli was given up by her parents at an early age and she lived throughout her youth in the southern regions of Mexico aquiring the languages of the many different tribal peoples among whom she lived. When Cortés arrived to Mexico, a gift was given to him of many women, and

among them was Malinalli. In very little time, the Spaniards discovered Malinalli's gift with languages, and her ability to translate and speak on behalf of Cortés made her his favorite consort. She traveled everywhere with him, and is mentioned many times by the famous Spanish chronicler, Fray Bernal Díaz de Castillo (1992). There are codices painted by the Aztec scribes enslaved by the Spaniards in which she appears, dressed in native robes, standing by the side of Cortés, with the traditional symbol for wind, or speech, coming out of her mouth. She became Cortés' lover and, in time, had a son for him. This is where the notion of her as *la chingada,* the "fucked one," the "raped one," comes from. In his book *The Labyrinth of Solitude,* Octavio Paz (1959) writes a brilliant description of how we, as Mexicans, have identified with this notion of being *chingados* because of our historical cultural origins.

La Malinche
llorona
sufrida

What is the difference between →
↳ Self-abnegation / Sufrida
↳ Institutionally Demanded Sacrifice and Piety
↳ Willing Sacrifice ?

La llorona + La Malinche play into this!

Madre de chingados

Her sister crying — punished "evil" voice.
Honest about sins —
 Myth of forgiveness
 Women forever marked
church annulment / divorce...

Page 37 (back) from Field Journal

This is when the legend becomes polysemic, when the multiple meanings begin to jump out, when the various political interests latch onto the narrative to make her story theirs. In the 1999 film, *La Otra Conquista,* Malinalli is portrayed in a historical fiction as a woman who was shrewd and masterful and used her translation abilities to send secret messages to the native Mexica peoples. She is portrayed as needing desperately to bear the child of her own people and, when she becomes pregnant, it is the descendent of one of the Aztec rulers she carries, not Cortés. In this narrative, she has never really "sold out" her own people.

The more common narrative is that she did exactly that—sold out. She was seen as a traitor to her own people, making love and bearing a child for him. This child is seen as the cursed future of the Mexican peoples, forever mixed with the bloods of warring peoples, with the sparring of the Spanish racial caste system encoded into each and every mestizo born from that day forward. It is from this story that we get the term *malinchista,* and, whenever I have heard it used in Mexico, it is with great disdain for the person who is seen as having a preference for the "other." Engaging the other is seen as a rejection of the Mexican. This kind of sparring is alive and well today in many forms. I remember living in Chicago in the mid-1980s and attending board meetings in the western Chicago neighborhoods, where the first moments of the meetings were spent in a sort of linguistic game of "what kind of Spanish do you speak?" There was a sort of pecking order from the more Castilian, Spanish-Spanish of certain Latin American countries, to Mexican Spanish and the Afro-Caribbean accents of Spanish. And then, of course, there were those who couldn't speak Spanish at all—those would be the most suspect. It's internalized oppression at its best—or worst, depending on how you look at it.

But there's another version of Malinalli's tale. This one is the sort of postmodern re/deconstruction that is based on wanting to reframe history so we can feel dignity and pride. The image of our ancestors being conquered and enslaved, raped and violently converted to Catholic Christianity, is hard to stomach, although it is the truth. The absolute lack of power of the human volition of our ancestors is, I think, too hard to accept—especially in the face of the socioeconomic challenges of our people in today's day and age. So the Malinalli narrative needs a little tweaking. We don't want to think we were set up by "one of us." And we don't want to think that by having a child with the Spanish, Malinalli was creating an inferior breed. So the third narrative we pick up is one where La Malinche is seen as the mother of the Chicano. A sort of prophetic visionary who could see the future of our peoples would be in the mixing of the bloods. This version is visible in many murals around Mexico that portray us as a *raza cósmica,* a cosmic race—made up not only of the Spanish and Indian peoples, but the Asian and African peoples as well.

I relate to her in a different sort of way—I see her as someone who was somewhat entrapped by her own ability to be who others wanted her to be, because of her superior abilities to communicate. We wouldn't know about her as we do if she had merely been the sexual consort of Cortés. In fact, there were probably many other Nahuatl-speaking women who satiated his prurient desires. But what made Malinalli stand out, enough to have Cortés named by the native peoples as her lover, is that she was indispensable to him—because of her language and speaking abilities. Some say further bloodshed was spared in the "spiritual conquest" of the Aztec peoples because of her ability to persuade. I wonder what it was like to live in her body, to have that gift of the voice.

Letter to Malinalli, *la Malinche*

Malinalli,

I don't know how to address you. I wish I knew your language, wish I could talk to you in Nahuatl. *Tengo miedo que el Español te vaya despertar malos recuerdos.* Is it that way for you?

I understand a little bit of what it is to be able to move between two cultures, because you can talk like both of them. I also know how it feels for your heart to belong to one, but to have people hate you because your tongue belongs to the other. I know what it feels like to be rejected by my own people because I can talk like the ones that are considered the enemy. I guess that is why I wanted to write to you. *Me he sentido muy sola, y siento que ud. tambien ha sentido esta soledad profunda … que tiene su origin en la lengua.*

But I also want to talk with you about something maybe you haven't talked about before. I hope it is not too private. It's just that I think you might be able to help a lot of us understand what we do in our own lives. *Nosotras, las hijas de la Malinche.* That is what they call us—*bueno, a todos—nos dicen, "los hijos de la Malinche." Pero como insulto.* It is not said as a compliment. Sometimes they even call us *Los hijos de la Chingada.* That's what I want to talk with you about. I know it is a hard thing to talk about. *Pero a mi tambien me han chingado—y si no me expreso, siento que siempre estaré chingada.*

They think we like it, Malinalli. How do we explain that the strength and resilience that comes from surviving abuse and rape is not because we think we are better than others? That the way we stand with dignity and our heads held high beside our oppressors is not because we are proud to be by their side, but because we refuse to let them take our spirits?

They use your name now in this beloved Mexico to insult each other. *Cuando alguien prefiere a los otros, a otras culturas, a irse de México … dicen que son Malinchistas.* But you didn't choose to reject your soul, Malinalli, and neither do

those who tire of the subhuman wages and living conditions which force them to move and work for *el extranjero*—to learn *inglés,* to leave for *el otro lado. Y al regresar ... a ser Malinchistas.*

Yo se que si existen los que si actualmente rechazan a su alma Mexica. Maybe that is why it is hard for people to believe we have not. Because if people who are *not* as good at speaking the other languages, if people who have *not* been forced to sleep with the enemy, if people who go around preaching their love for Mexico—if they, who *seem* no different, really do reject México ... *¿entonces cómo van a creer que nosotros no?*

¿Cómo lo hacías, Malinalli? How did you keep your Mexica heart beating to the rhythm of the earth? When they changed your name and called you Marina, when they ripped off your feathers and made you wear lace, how did you remember? *Porque nosotras, tus hijas, las Mexicanas, las Chicanas, necesitamos esos secretos.* We are killing each other's souls without the secrets. We have never lost the anger that our ancestors felt when they were being beaten or burned and enslaved, when they would see you with your *jefe, tu amante, tu queridísimo señor, el Hernán Cortés. Veo ese mismo ira en los ojos que me miran con desprecio mientras me aplaudan al lado de los gringos en nuestro mundo Chicano. ¿Cómo lo aguantabas?* How did you put up with it—and how did you stay faithful in your soul? How did you remember Ometeotl and Quetzalcoatl when they marched you in front of the cross? How did you remember Tonantzin when the wooden statues of their lady stood before you? How did you remember when you traveled with him and he made love to you after burning your people and their villages? How did you remain Mexica while you smelled his sweat and felt his flesh, heard him uttering your name, *Marina,* in his filthy conqueror passion? *Perdóname la indiscreción, Malinalli,* but I need to know. Did he molest your daughters, too?

Did you do what I think you did? Did you do what I think so many of us have learned is the only way to survive as women in this new *mundo fregado* that they brought to us? Let them have your body, but not your soul? Did you learn to love your *señor* in plain sight but to have your heart beating somewhere else?

Because I think that is what we all do, when we are taken without our consent. And after a while, that is what we think is the way it should be. *Y nuestras lenguas* ... our tongues belong to them ... so we only use them to say what they would have us say. It's the only way you could stay alive, wasn't it? And, in a funny way, it was the only way you could still know what was happening in the world they took you from. By walking that road between cultures for them ... you could still connect with your soul.

Pero, perdóname otra vez ... es que aunque comprendo esto ... even though I understand what you had to do, and that this is the way you made it possible for us to

keep living. *Pues, Malintzin, ya dejó de funcionar. Ya no se puede.* It can't be that way anymore.

I want your blessing, Malinalli. *Quiero tu bendición.* Because I want to quit being *chingada.* And I want to use this bilingual tongue to destroy the lies, not build them up. I need your help, *Madre. Lo quier hacer en tu honor.*

I want to push him away when he thinks he owns me, whether He is an actual man or whether "He" is just the way all his institutions feel. *Ya no quiero que me chinguen en el nombre de dios, ni en el nombre del progreso, ni del poder económico, ni en el nombre de cultura o familia o tradición. Porque cuando me chingan, chingan a mi madre. Y ya no lo voy a aguantar.*

Por ti. For you, Malinalli. *Espero su bendición.* I will look for you in my own heart when I speak in your name. I will remember it is your sacred blood that keeps me alive and which I feel pumping in my chest. I want to own my indigenous soul and separate it from these nation states and *raza* mentality that is killing us. *¡Ya basta!*

Escucharé en mis profundidades por el viento de tu alma. And I pray for that sacred wind to protect me and all your children as I open my mouth to let it cleanse the earth.

Cristina

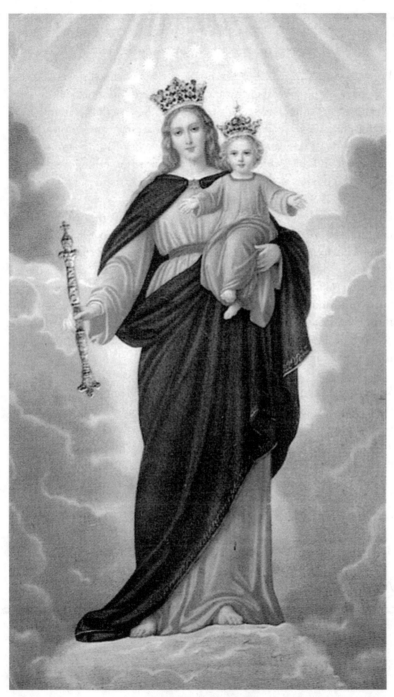

Mary as Queen

Prayer to *Nuestra Señora de los Españoles*

I pray to you, Mother—but I'm not sure exactly who you were. You are the image of the Lady that my ancestors, the *españoles,* brought to Mexico to my other ancestors, the *Mexica.* I believe that you hold a wisdom far greater than all wisdom that comes from the world—because I don't understand how you could be our Mother and stand by and watch and do nothing—so you must know something we don't know. You'd have to, or else … I just can't understand.

Do you know how to see a light that brings comfort in the midst of the insanity and cruelty of our humanity? I pray to you, sweet Lady, if it's possible, help me find what it takes when it seems that there is nothing that can be done to bring Light into the world. Teach me to see the forgotten ones who stand for Truth when it seems that the Truth is losing, and show me how to act from the heartache of compassion for those who suffer at the hands of those who believe they act in the name of God, in the name of Christ, and even, in your name. Help me to understand why it seems you do nothing.

When others concoct elaborate rationales for allowing themselves to torture in the name of their God, help me not to be silent, as you were, but to never quit speaking. And help me to have forgiveness for myself and others I judge for the times we stand silent while injury is inflicted on our brothers and sisters in the name of what is good and true.

I have a lot of trouble with you. I need you to prove to me that you care.

Then maybe I can feel you are my Mother.

Amen.

Malinalli's Gift

a merciful fog has come
softly blanketed embers burning
from a long-ago blaze I cannot forget
cannot stop seeing in the eye of my soul
anxiety rising within
crying with the anguish of a foster child

I have kept my eyes
on the idol of my life's story
and my ears have focused all too much
on my own tale
was it You I sought
or the certainty that I could explain each turn?

my voice—always my greatest ally
my repentance truly only desires to be good
fear-based insecurities
turning each time away from the
eternal sound of nothingness
that ocean of maternal waters
that would birth my heart
preferring instead to gaze at the faces I created
to listen to the din of the many voices of my lives
to fascinate myself as much as the others
with the credibility of my half-truths
the fluency of my many tongues

such a subtle turn
turning from the embers
to the flame instead
it is hard to turn away from the idol
when the idol has been me
hard to listen for Your voice
when I have heard no other but the one I've called mine
the one I've used to satisfy
the images of me invited
by the Others.

today we no longer burn sacrifices
or carve out our hearts on temple heights
the ark is missing
and the rituals lost
I sense it is time
however for my greatest sacrifice

there is no yesterday or tomorrow
no up or down
there is no east or west
north or south
and there is no "I" apart from You
I am frightened
but I must walk away from me
and all I have used to create my social being
all I have done to know I was good
speaking whatever truth would prevent
anticipated punishment
whatever truth would invite acceptance

the fear of solitude
misleading me
away from You
validating the sources of purgatory's flames
invalidating Your eternal flame

I cannot follow the sound of my own voice any longer
the words of my mouth
and the meditations of my heart
have been strangled by my own hands
it is time for the chokehold to be released
time for the words to come from You
time for my walk to take me to You
the stories must lead to the place
where the truth is found
my journey has been far too long
to keep moving in the wrong direction.

Letting Go of Malinalli's Legacy

It is said that those things that trigger the most intense and obsessive emotional re-actions in us are aspects of our "shadow," those parts of ourselves that we refuse to see because of the ways we have been socialized, the way our egos have identified, because of who we think we *are*. These triggers lead us to those aspects of ourselves that need healing, that used correctly, and in an openly appreciative manner, can be the force behind divine creativity. This is what I teach my students, and what-ever I have taught in the classroom has inevitably been part of my own personal learning and journey. I promised myself upon receipt of my Ph.D. in 1986 to never require anything of my students that I myself had either not already done or was not willing to do. It's something I take very seriously … and it bites me in the foot quite often!

As someone who began studying speech at age 14 and never stopped, some-thing that has triggered me about the work we do in the field of communication is the facility with which a truth can be camouflaged, a lie hidden. I've spoken out against the inherent lying nature of the field of communication, the evildoers be-hind every presidential campaign, the wicked wizards of television advertising. When I was in college, fighting my father's demands that I go to law school, I simi-larly decried the legal profession as "not *lawyers* but *liars*." I proudly boasted to many how when being promoted to head a new department, I told the vice presi-dent, in the presence of the university provost, "I will work very hard for you, but I will never lie for you." The people in my life who have lied about me have tor-mented my nights as I obsessed on the possible harm the lies could do to me. Might it be that this obsessive emotional wrath against lies could be a reaction to an aspect of my shadow I'd not had the courage to face?

In fact, like Malinalli, *la Malinche,* I have been gifted of the tongue from early childhood. My first experience as a public speaker was at age seven at a summer re-ligion class. I stood before scores of other children and their teachers and told the story of Abraham being asked to sacrifice his son Isaac, and I realized I could do something other people had trouble doing. I was comfortable speaking in front of others. I could convince a whole neighborhood of children to join me in forming a club, exploring the forest, or holding a carnival. At age five, I had already learned that I could even stop my mother from spanking me simply by using my voice forcefully and saying, "Look at you! You look like a crazy person—go ahead and hit me—but look at you!" She stopped.

During our religion class in second grade, one of the nuns at school told us that it was possible to "lie without lying." I think what she was trying to teach us is that we needed to be careful and always tell the truth—and that we needed to con-fess when we had lied even when it might have seemed we were telling the truth.

However, this is a realization that truthfully, I only reached a few years ago. Until then, I somehow heard the wise woman at St. Mark's Catholic School as having taught me how I could get away without telling the truth by telling partial truths. Perhaps somewhere in my genetic memory as a descendant of Sephardic Jews in Spain and Aztec Mexica natives in Mexico, I was already programmed to know that we can tell half-truths and avoid negative consequences. After all, Mexicans and Chicanas cannot escape the historical legacy of the Spanish Inquisition that shaped our culture, our politics, our religion, and our everyday sense making. The lesson of the nun was a seed that found a soil hungry for the appropriate rationalization to help my fearful ego. I quoted her throughout my life to support my developing life pattern of obfuscation, subterfuge, and internal collusion. I developed a personal style of communicating that was rarely the full truth, but always at least partially true. Fear of punishment motivated me at every turn to seek the truths others wanted to hear. I publicly held the philosophy that one should always express the truth, but I only practiced it strategically. I was blind to my hypocrisy.

I think that in a society, everyone learns to hide his or her essential self. But I went through life purporting that I hid nothing, that I was open about myself, when in reality I was no different than anyone else, except perhaps in my fear that my secrets would be uncovered. There is no way that I could write this book without confronting the reality that, in my life, I had never fully been my self, although I went around decrying everyone I met who was not fully authentic. At one point, I think that I even began to believe that I was honestly being myself. My ego worked overtime to hide the jewel that was hiding inside me. And it made me despicably self-righteous as well.

Over the years, I refused to let go of my self-image as someone who always told the truth. And I worked overtime at creating public scenarios to reinforce what I wanted to believe about myself. If someone needed someone to confront others at a meeting about "the truth," you could rely on me to do it. I had little respect for authority or position or power if there were lies to be uncovered and revealed. I attacked the field of communication, Chicano and Chicana studies professors, university administrators, the Phoenix City Council, dysfunctional Native American organizations that hired me, and Arizona Hispanic leaders in business and politics. I spoke out against child abuse, sexual abuse, cultural discrimination, police violence, and the inadequate communication of therapists and physicians. In my family, I pulled off the cobwebs and sheets from many a family skeleton in the closet. I took the patriarchs and matriarchs off their thrones and stomped on family legends. And I tortured my graduate students by revealing each and every deviation from absolute truth that I could detect. I made more than one cry. As I look back at this self-righteous person that I was, I wonder that I could not connect my behavior with my separation from myself. You see, I had no idea that I was really

not honest. I could not understand why people feared me or resented me. All I could see was what my ego wanted me to see—that I was a defender of the truth. And a lonely one at that.

My loneliness was not because I had no friends. No—in fact, I had many friends, and good ones. I can see that now especially, as I realize that many of the friends I made over the years who remained my friends were persons who had tolerated my heated diatribes. No, my loneliness was not for lack of friends. Rather, behind the confident façade and bold expression and social risk-taking that I was known for, I was terrified. And I never told a soul, never reached out for help. Despite my incredibly intricate extended family and network of friends and family, no one knew me. The fact of the matter is that I did not know myself.

The psychology of the ego is so basic and ubiquitous in our popular culture that it is almost cliché. To write that my ego was created by my socialization experiences—my culture, my family, my religion, and the relationships and traumas in my life—doesn't seem to say enough. Something seems to be missing. And I think what is most often missing is the spiritual nature of the dynamics that the development of the ego sets in motion.

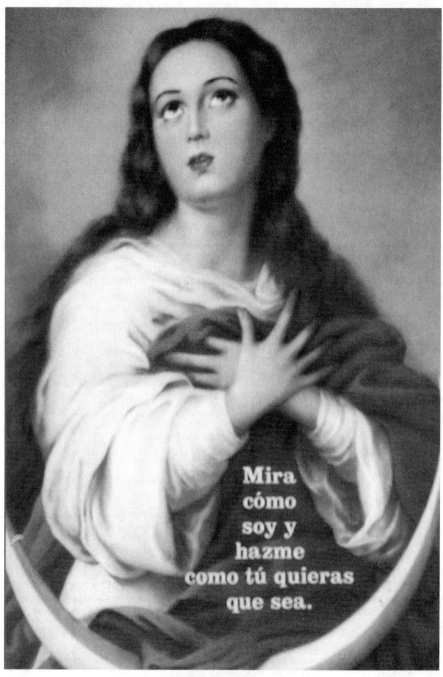

Mira
cómo
soy y
hazme
como tú quieras
que sea.

Mary's Prayer
See how I am and make me how you want me to be.

Raised as a Catholic girl of Mexican ancestry in southwest Texas, I was raised to be "good." I was the eldest child of my generation on my father's side of the family, and the eldest of the younger generation of children on my mother's side of the family. It was my job to "take care of things," to make sure others were not hurt, to help others accomplish their goals. We were not economically well-off, and I was taught that it was noble to give up what I wanted, that to satisfy my own desires was selfish and not loving.

> Mother held my face in her hand
> Tight fingers in my little cheeks
> Four years of life
> Not giving me the wisdom
> To know she was crazed
> Shaking my face
> After whipping my body
> For having bought jawbreakers
> Irony
> Now she held my jaw
> Now she broke, not my jaw,
> But my spirit
> For having bought jawbreakers
> Instead of potato chips
> I was nasty
> Dirty
> Stupid
> A child
> With my tears making
> Her fingers slip
> As she held my face
> Over the toilet
> Where nasty things belong
> Like candy jawbreakers
> That she forced me to watch
> Fall into the water
> Flushed into a septic tank
> Whose mire
> Would never match
> What was created
> In my soul.

My father was often violently raging and an unfaithful husband. I learned that the ultimate "goodness" was to make him happy and prevent an outburst. That would keep my mother happy, too. Things were especially harsh when it came to money. I learned that the way to get money for the things that I needed was to ask for more than I needed, since I would inevitably get less than I asked for. I also learned in time to ask for things that I had no intention of getting, so I could get extra money, in case I needed it later, and I wouldn't have to ask again.

To avoid a fight between my parents, the best way was to cover up what I knew about the other. And I would hide away my little brothers, when the atmosphere was particularly tense, and would tell stories to them to keep them entertained.

Meanwhile, in church, I was learning that God seemed to operate in the same way as parents. At least the God of the Roman Catholic Church as represented by the authority of the Vatican. Confession before communion taught me that even if I did not have a sense of my sinfulness, it was a good thing to have "good sins" to confess on the first Friday of each month when the nuns took us to church.

> confession
> Sitting in "solemnitude"
> in shiny mahogany pews
> That are too big for
> My seven-year-old body
> Bony little knees
> Digging into hard ochre vinyl kneelers
>
> It's supposed to mean we're like Jesus
> For our knees to hurt while we kneel here
> Jesus suffered so much more
> At least we only have to kneel to pray
> Jesus …
> JESUS
> JESUS was CRUCIFIED.
> Put on the cross for all to see
> Nails in his hands and feet
> Hands and feet
> Agents of expression and mobility
> Hands and feet
> rendered fixed.

And there we kneeled, squirming
Planning our confessions
Bless me Father
 for I HAVE SINNED ...

Oh, little seven-year-old mind ...
I HAVE SINNED
It is so good to tell how bad I am
Waiting
 kneeling
 make-believe preparatory prayer
Learning make-believe penitential posturing
What shall I tell the priest
What shall I tell ...
 FATHER
I can't remember any sins
but we've all sinned
Believing I haven't sinned
 is a BIGGER
 Sin.

Second-grade mind
making up sins to be confessed
Learning early the meaning of
 CONTRADICTION
CONTRA ...
 DICTION.
To speak against one's word—
 To act against a vow...
Confessing my sins to ...
 FATHER

Bless me father,
 for I have sinned.

It has been one month since
 my last confession ...
I lied to my mother, I lie ...
Endless ellipses of truth and untruth
Paradoxes of forgiveness

 not ever quite enough
Always, I return to the kneeler
 Genuflect
 and bless my self
Oh, bless my self ...
Oh my God, I am heartily sorry
 for having offended thee ...

Heartily *sorry?*
Like a good heart-filled laugh?
Learning to laugh at my sinfulness ...
To laugh at my sinfulness ...

The lessons the nuns never taught.

In third grade, I wet my pants in front of the entire class when the nuns' instructions that no one be allowed to go to the restroom during lunch were upheld despite my asking three times if I could go. The nuns removed my underpants and rubbed my "private parts" roughly with brown paper towels while they told me a story of a cardinal in Rome who became a saint because he held his urine while waiting to vote for the Pope. This alleged cardinal died because his bladder burst. The point was, I was told, that he was made a saint ... because he held it. Unlike me. I learned that the ultimate way to show God I was good was to control my body's natural functions. Current revelations of clergy's inability to do just that make us realize the hypocrisy in what I was being taught.

My sexual abuse experiences in early adolescence reinforced these lessons, coming just as I was becoming increasingly self-conscious about my changing body. I learned to hide myself behind a homely façade, not wanting to attract too much attention to my body. It did not feel good to be looked at. So I hid behind my brains and let my sister Linda be "the pretty one," while I was "the smart one." At this point, I was internalizing a sense that somehow my natural self was the source of all evil in my life.

 the tips I received growing up
 seemed so obviously misguided
 "Put on a little more blush."
 "Put on something nice."
 "Wouldn't you like to cut your hair?"
 Suggestions from loved ones
 Always something to improve my appearance

"You look so pretty when you fix yourself up …"
But I am wicked when I am pretty
Ugly when I am myself.
Don't they know that I *have* to be ugly to be good?

I could go on with many more examples of how I was socialized and taught throughout my life that a dishonest representation of me was what the world around me invited, wanted, and rewarded. An honest representation was punished. In fact, to go on with the examples is exactly what I learned to do in therapy—which is where I wound up, after my lifelong pattern of "doing what I didn't want to do and making it look as if I did" led me to marry a young man who physically abused me from the first day we were married. This is when my ego went into overdrive. You see, until then, I had not had any trouble being known as a good girl, because I played the part constantly and consistently. But when I married this man, and had to *divorce* him, I was now officially "bad" in the eyes of the Church … forever. And my grandmother took back her wedding gift. So I was bad in the eyes of my family, too. That meant that now the ego needed to find another way to keep me "good." And therapy provided the way.

I learned in therapy that I could put the skills of communication I had been studying in college and graduate school to good use. By telling stories of my life's woes, I could get the support of others. I learned that these personal narratives were becoming sources of political power in my academic work as well. Before I knew what was happening (quite literally), my ego had quickly jumped in, learned the script, and propelled me into the way my life would be for the next 15 years. I would learn to tell stories about my life and history that were true. But in telling them, I would cover up the bigger truths. The problem is, I did not really know what the bigger truth was. I was afraid to let people know I was afraid. I thought the truth was that I would be punished.

Now I have to speak honestly or, in this book, I will be doing the very same thing I have always done—telling truths without telling the whole truth for fear of negative repercussions. You see, on the surface, it would seem that the reason I have come so far is that I have had the courage to tell more stories. That somehow telling the stories is what has liberated me. In fact, telling the stories *has* been helpful, but not because the stories are true to some external authority: cultural, religious, or political. Self-definition and personal sovereignty is vital to human agency. When that is externally determined, severe oppression of the human spirit occurs, and all relationships affected are equally oppressed. Malinalli, "La Malinche," could tell stories to satisfy her audiences. I have grown up that way, too. Now I am telling my stories to undo the fictions of truths that I had created

over the years. Perhaps it will open the door to my own healing and that of those with whom I relate.

> it is the early late hours before dawn
> and my heart wakes me to be with the
> Beloved
> this is the place of darkness
> where there is no fear
> this is the hour of silence
> and of nothingness
> when all things have been made.
> I have found a secret passageway
> a secret doorway to a resting place
> so Divine
> so austere
> so absolutely brilliant in its simplicity
> it is my own heart.

8

The Journey of the Shapeshifting Woman

in the early morning I hear the
melody you send
the calling of the four directions
sacred breath blowing through a
shell
awakening the primal link I have
to you
Tonantzin
earth mother
madre tierra
Guadalupe?
is that you?

Tonantzin
are you there, *madre?*
is it you that calls me with the
morning song
is the serpent on your face hidden
are you watching me with the
same eyes?
when I pray to you
is it you that hears my voice

is it you that comforts me?
do you need my heart still, my
mother
my life
my breath
surrender without fear
or have you changed?
so many clothes
so much covering the sacred body
truly, *madre,* I want to know
is it really you?

Tonantzin
 madre
 Guadalupe?

where is your fierceness
where is your dance
gentle, kind mother
is there no anger in you at our plight?
madre de las Américas
what are you waiting for?

> *Tonantzin* *Tonantzin*
> *Guadalupe* help me find you.
> is there something we don't see?

Who Was Tonantzin?

She was the "earth mother," the "mother God." Her name was an endearment—she who loved the earth, the mother … a kind of circular love of love of love. She was "mami" or mommy, and her home was at Tepeyacac. Each year, millions visit her traditional home on pilgrimages. The stories John Mini has gathered in his book, *The Aztec Virgin* (2000), are some of the best I've been able to find. He is writing about Guadalupe, of course, but in doing so, he has to address the nature of the earth goddess/mother in the Nahuatl tradition. This is rarely done by those who write about Guadalupe to strengthen the Church's stronghold on her image, as in the work of Jeanette Rodríguez (1994).

To me, Tonantzin is like a great void. I believe in her, but I don't really know her. As such, I can have whatever kind of relationship I want to have with her. So as I birth myself, I, in a sense, become Tonantzin. I feel that by peeling away the layers of "Mary" that had hidden my mother-self from me, I am just now beginning to birth my indigenous self. I find the woman with the heart ready to be bared for my life's purpose. But it is a fragile, frighteningly new feeling to have that purpose not come from my mind—to know it will be revealed. And I feel I need to know this Mother more intimately and the God that is the One that holds everything in unity. It is funny, because the Christian tradition is that Mary draws us to Jesus and to God. I find Tonantzin drawing me to Ometeotl, the Aztec name for the one divine source/power, the union of all duality in a dynamic power. For there can be no Mother without Father, and truly these journeys will keep me traveling for a long time, like my ancestors on their pilgrimages to Tepeyacac. I must keep moving.

In the movie, *La Otra Conquista,* the opening scenes show a ritual that is performed to Tonantzin. In it, a young woman gives her life by sacrificing her heart in order that Tonantzin will protect the sacred history of the people. The young woman eats a mushroom and prays that she will forget the past and the future—she is clearly frightened as her painted body is laid on the altar to Tonantzin and the shaman plunges an obsidian blade into her chest, reaching in with his bare hands to take her heart.

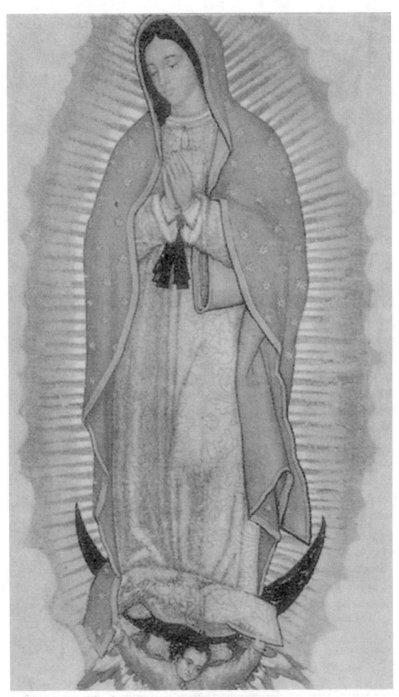

Our Lady of Guadalupe

There is something I liked about this ritual. Not the visceral, literal enactment of the human sacrifice, but the significance of dying to one's past and future in order to make the sacrifice that will bring the protection of the Great Mother. In a sense that is what I have been doing with these journeys. And engaging Tonantzin is the step to the altar of sacrifice.

> ### Prayer to *Nuestra Señora de Guadalupe*
>
> *Ay, madre. No te puedo hablar en inglés.*
>
> *Madre mía,*
>
> *Eres la imagen que nos ha sostenido por siglos, y hoy le pido que me ayude con la batalla de imágenes que me confunde tanto.*
>
> *Abre mis ojos para ver la verdad. Llévame a los caminos que llegan a descubrir lo que nos han ocultado de nuestra vista cultural, nuestra vista personal, nuestra vista espiritual.*
>
> *Ayúdame a escuchar los sonidos de la música eterna, la que me podrá sostener durante la guerras espirituales de esta vida material. Llena mis sentidos con los olores de las flores que celebran la vida que sigue sin el esfuerzo de la mente humana.*
>
> *Madre, deme la fuerza para no representar lo que me da la gana, o lo que me mas conviene, cuando la verdad duele, o cuando la verdad no me gusta, o cuando la verdad me amenaza la seguridad social, económica, o emocional.*
>
> *Y por las injusticias y mentiras de la historia, enséñame, querida madre, a saber como llenar mi corazón con la verdad de mi vientre, como escuchar con mi mente la voz de mi corazón, para expresar bien con mi boca el viento de las palabras que cambian el mundo.*
>
> *Te amo, Tonantzin.*
>
> *Amen.*

Letter to Tonantzin

Tonantzin,

As I sit here with my pen in hand, wanting to write *you*, Tonantzin, I find that it seems artificial. You see, of all the women on this journey of mine, I have kept you 'til the end. With each of the others, I could find ways to connect. I could see how my life has had common themes and threads. With you, *madre Tonantzin*, it is different. I believe in you, but I do not know you. No. I *chose* to believe in you. Chose to own you as mother. But who are you?

First of all, I should probably address you in your language—the language of my own ancestors, but a language that I did not even know existed until I was a woman: Nahuatl, language of the Mexica peoples, the language of Emiliano Zapata and *la revolución*. Would I be better able to find you in my heart if you were part of the way I speak and see the world? If the language I used to talk with you was the language of my ancestors, when they *did* talk with you? *Madre tierra,* grandmother, earth mother, *Tonantzin.*

It is as if I have been an adopted child and in my middle age am discovering my birth mother—the one I never got to know. Was I taken from your breast or did you give me up? I don't know, Tonantzin, I don't know. They say you are Guadalupe. That you came to us in Guadalupe, to show us the way to follow. I just don't get it. I want to. I do. But what is it that I want to feel? What is it that I'm supposed to be so mad I lost? What is it, madre?

Soy tu hija, y no te conozco. I am your daughter and yet I do not know you.

Or am I finding *you* on this journey as I travel through the mysteries of what it has been to be a woman in this life of mine? Is this what we have lost, madre, in losing our connection to the earth? Is that the way to know you? Does the journey through the terrain of my own life put me in touch with you, with the earth? Is this how we can learn to preserve the earth—to preserve *you?*

Is it you, *Tonantzin,* who speaks in the voice of Malinalli? Is it you in the guise of *Cihuacoatl,* patroness of women who die in childbirth, who cries in the wailings of *La Llorona?* Is it you in the distanced pain of Frida's eyes, you in the silence of Sor Juana's last years? Are the answers to the mysteries of my life found in the parallels of all women's lives—is this how we can come to know the earth—is the earth the holder of these truths? Are you the earth?

They say you are a woman of many faces and these journeys I have been taking are leading me to see the same about myself. But the faces you show are faces I have not yet come to know well. *Coatlicue, Tlacolteutl, Llamateuctli, Cihuacoatl, Citlalli Icue, Teteoinan, Toci*—only a few of the faces you bear. Are these the faces hidden behind the mask of Mary—is this how you are speaking to me, *Toci,* my grandmother, my *abuelita?* Are you hidden in her face—do I find you by finding you in my own stories?

This is the mother they tried to put to death in the Inquisition—the mother hidden by the face of Guadalupe? It is the woman who lives in each and every one of us. And I am beginning to see, *Madre Tonantzin,* that when I told my stories in order to please the authority of some external source, I lost my connection to all that is sacred. The stories are sacred because they bring me to You. You are the earth, the creation that is good. And in understanding the mysteries of this creation, through our lives, we become One with all things, with all beings, male and female, animal and plant, earth and water and air. I am beginning to see, *Madre Tonantzin,* this is the woman I am, who has been hidden from my own view in the many faces of María and Mexican women throughout my life. They held the truth, but their stories were too tightly woven—they did not hold the threads of my own being. This is the woman I have hidden with the stories I have told to satisfy the narratives of the false world around me. Each time I withheld even a tiny fiber of reality, of truth, I grew away from you. That is the price of the Inquisition, of moralities that cause us to tell partial truths, to hide our lives or distort them in the name of propriety, honor, or tradition—maybe even God.

I learned that when you begin to speak through me, I should be punished, tamed, silenced, or killed. You speak through us all, don't you, *Toci?* And when we begin to tell our stories for effect and not for truth, we begin to destroy our very essence. That is surely what we have been doing to your body, to the earth. And today I see, *Madre Tonantzin,* that until I embrace you fully as my mother, my Source, the feminine spark of God *in me,* I am truly powerless. All strength and power I claim from a story told for any other reason than to unite me with the One of all creation is false power.

Somehow, in coming to believe in the authorities that can punish me, I have distorted the ultimate authority of truth. It is hard to see things differently just yet, Tonantzin, but I think I am beginning to. It is all one story. We are all one people. The veils we wear in one corner of the world remind us of how easily we can hide the true power and fire inside us—the power and fire that we should never forget. We are the vessels which house the Shekinah, the indwelling presence of the Creator. Our life stories can always take us back there. And it is in your faces and dances, in your throes of agony and ecstasy, that we find the divine tension into which we must surrender. It's not about being right or good at all, is it, *Tonantzin?* Every pain or joy in these humanly embodied lives is just a road of *being.* Of realizing Ometeotl … the Echad … the Allah … the One. You birth us, and we birth you, when we accept the breath of life, the *ehecatl, the holy wind* that will accompany us along the journeys of our fully embodied lives. It is all One. *Toci. Grandmother. Mother of mothers.*

María Cristina

Coming Home by Shapeshifting

an obsidian blade held above my heart
Divine Mother calling me from ages long forgotten
This longing, like a deer
For rivers lost in smoking mirrors
For a melody faint but pure
This search for what I claim I am.

Chicana. One would wonder why I would hold on to a term that has so much power to hurt me and has. My extended family is ashamed of it, acknowledges it, but uses it only in pejorative humor to refer to us—*la chicanada,* when we are a little too obviously of the earth. But they wouldn't say it that way. When we are a little too unconcerned with social convention. When we are not so neat. When we are a little too vulgar. When we do something that would embarrass us, in front of *them:* The *gabacho,* the *criollo,* the *Español,* the *gringo.*

That is how I grew up hearing the "Mexicans" in my Texas hometown use the term. The efforts of the League of United Latin American Citizens (L.U.L.A.C.) and the G.I. Forum had succeeded in having us classified as "white" so that we could enjoy the privileges and rights that had been denied us since the United States obtained Texas from Mexico with the Treaty of Guadalupe Hidalgo. It was a kind of confused, hegemonic ploy that bought into the centrality of "whiteness" and reached back to our Spanish ancestry to say we could play, too. But it was nothing new.

The caste system in place in Mexico during the colonial era had already placed the hierarchical racial structure in our psyches. "Pure white" from Spain was best—Indian, worst. Combinations with Chinese and African were down the ladder. So, the more Spanish we were, the more privileged, the more *human.*

Chicana. Or should it be, *Xicana,* with the "X" used by Spanish scribes who had difficulty transcribing the sound somewhere between "sh" and "ch" and located somewhere in the upper regions of the throat. Much debate exists about the origin of the term. But it was the term owned by the 1960s social revolutionary movement of *La Raza.* What had we given up in asking the government to classify us as "white" so that we could gain admission to schools, eat in restaurants, and swim with our Anglo counterparts in this bizarre ethnic dance? The word *Chicano* frightens those who have internalized the racial hierarchy. If our access to a decent life is rooted in proving our similarity to "them," then anything which accentuates that we are "not like them" is dangerous. Even if it is true. Maybe *especially* if it is true.

Chicana. Owning our relationship to the *Mexica* (Meh-shee-kah), the *Mexicanos*, we are *Xicanos*, we are Indian, the Aztec peoples, an intertribal nation of nations whose people blend as a way of life. We claim our right to a sovereign identity not based on identification with a conqueror, an imposed religion, or our colonized nation of citizenship. We claim our right to a sovereign identity whose spark has never died. We are the indigenous people of the *Mexica*, with our identity rooted in a spirituality of the earth and skies. *Tambien nosotros somos hijos del dios del cielo y la tierra*. (Such was the cry of Topiltzin, the composite Nahuatl character in the film *La Otra Conquista* [1999], in which the gradual spiritual conquest of the Mexica [Aztec] peoples forced them to replace their reverence for the Earth Mother Tonantzin with homage to the Virgin Mary.)

Chicana. My claim to an identity rooted in a search for what has long been lost to our conscious mind. A claim which in some ways distances me from family and community, hegemonically identified with being Mexican American, or even Hispanic, in efforts not to be so different that we will suffer for it. I understand it. It makes me cry.

Chicana. A claim that binds me to others who, with me, wish to become one with the earth, who want to reach Spirit without Western religion. And yet, we do so feebly, with five hundred years of colonizing efforts between us and our traditions. With imprints of western religious structure firmly pressed into our consciences, complete with dysfunctional patriarchy and matriarchy, beliefs in rigid orthodoxy, and fear of freedom.

Chicana. Identifying with this term, I join a community of others who also prefer to identify with a search for a smoky ancestral truth, rather than a clearly stamped imposed distortion. But truly, in the end, we have no real agreement about what it means to be *Chicana* or *Chicano*. There will not come a day when we will suddenly function as a smoothly operating machine, when we will not fight over who is, or who isn't, "one of us." Because it's really not about that—this struggle. We are still slaves to the caste thinking, even when we think we are nobly defending our ethnic honor. We've found something that makes us feel alive, that has put us in touch with the truth, and it is terrifying to consider that we might not be allowed to be part of it. Perhaps it is the souls of the Sephardim within us, remembering our forced conversions and being called swine, *marranos*, on the eve of Columbus' first Spanish journey to the "new world." Oh, we are such a hurt people. Why couldn't it be easier?

I have come to believe that any time we focus our efforts on defining ourselves "once and for all," whether as a group effort or through acceptance or rejection of individuals into our social world, we are gravely misdirecting our passion. Gloria Anzaldúa (1987) wrote to us of the "culture of the borderlands," which we wrestle with as persons of Mexican ancestry living in the United States. These tensions we

feel are signs of this culture. We make meaning in a culture that from its very inception knows that no meaning is hard and fast. We are comfortable in a culture that in many ways we know will never feel comfortable. Our legacy is *Ometeotl,* our divine deity of dynamic and integrated duality. It is *Echad,* the great One.

A person's primary culture is the system of meaning that he or she lives with others and which is taken for granted, which is taken as "natural" social behavior or interpretation. The postmodern era has invited us to consider a relativist viewpoint where we realize that there is *no "natural" social behavior or interpretation.* We recognize through this perspective that people have the ability to choose and deconstruct the things they've taken for granted. As Chicanas and Chicanos, we did not wait for the postmodern invitation to do this. We were born consciously swimming in a sea of ambiguity. It was not a question of our intellect having to make it possible for us. The need for spiritual survival as the basis for dignity in human existence brought us the truth. Even if the powers that be reject or spurn our identity, we still have the right to own it. We do not need to accept the terms used to talk about us nor the religion that we are told is ours. We can choose to return to ways we have been told are dead. We can choose to adapt those ways. We can even choose to use some of what we have claimed we reject and use it for our own purposes. We can *reconstruct* what we have deconstructed. The temple can be rebuilt, and it is our own embodied lives.

> with a new name
> and unbound feet
> I listen for the music of the ancestor within
> who knows not one tribe
> tradition
> or creed
> but dances to the rhythm
> of the earth
> and sees my roots
> connected to the tree of all people.

It is almost as if there is a thin veil differentiating the experience of the postmodern as simply creating new rigid systems of membership and authority and the experience of the postmodern as a manifestation of the smoking mirror that invites us into the world of *Ometeotl*—our dialectical ancestral god of divine tension. In this world, the tension of identity that we experience is divine. It is the whirling mass from which we are created. Instead of fighting it, to find the "one right answer," the key is to enter it and find the "oneness" in the tension, in the

tumult, and in the whirling mass. It is *ollin,* the earthquake of *Tonatiuh,* the sun whose face graces the center of the Aztec calendar.

We are *divine.* We do not need to identify with a fixed form, no matter how sacred we may have determined it to be. When we do so, it is for temporary purposes. Identification is static and, by its very nature, distorts *our* very nature. Our basic spiritual nature does not change in that it never stops moving! When we identify wholly with a temporal form, ideology, belief, or tradition, we forget who we really are. By calling myself Chicana, I have chosen to identify with myself as a shapeshifting manifestation of divine spirit. Much easier said than done. So be it.

As I understand it, when we shapeshift, we take on the form of another creature in order to accomplish certain ends. To do so is a solemn undertaking. And it requires highly developed awareness to pay attention to the nature of our purpose in the world so that we can take on the form(s) that is(are) necessary. Our ancestors acknowledged that they were shapeshifters. You can see it in the masks and the dances—when we become jaguars, eagles, snakes, or deer. Each form we take gives us abilities that are unique to that creature. We surrender those abilities of our human form until we return to "ourselves." As a Chicana, I am laying claim to this sacred ancestral tradition. And I am saying, I am *not* "this" or "that." I am. And my privilege and serious responsibility, as a part of this culture of the borderlands, is to recognize this potential, not destroy nor negate it.

A former student, Kirsten Broadfoot, now a professor in her home of New Zealand, sees this potential of having mixed or multiple cultural identities as having a "multifaceted cultural self" as in a crystal. If I choose to look through one face of myself, the world will look different. And if I adapt to that world, then I am also different. But if I turn and look long enough through another face, then the world changes and so, then, do "I." I must remember that I can turn my inner eye in any direction, that I can return to where I have been, or I can choose not to. But the action of turning is sacred: It is the shapeshifting.

When we vehemently reject aspects of our social selves as Chicanas or Chicanos, I think a number of things could be operating. Often, I believe we are rejecting faces or shapes we have realized were not taken by us voluntarily or by choice. These include issues of lifestyle, ways of dressing, foods we eat, and music we listen to, for instance, as well as internalizing competitive or materialistic cultural values or practicing a religion blindly. Politically, it is sometimes easier to reject those things that make us look like "the other," but it is harder to critique those things that make us look "like *us.*" So we critique ourselves and others on the basis of what we think it is okay to have identified with. I, for example, have often been criticized for my ability to express myself well in English as a sign that I am not a "real" Chicana.

The historical fear of colonization, as well as the present day reality of racism in the United States and Mexico, makes it hard for those of us who want to work for our ultimate freedom not to respond negatively when we are triggered by whatever aspects of colonization or racism have hurt us most. I have a hard time when anybody is too orthodox Catholic, for instance. Others get triggered by someone simply having legitimate authority in a social situation, the simple presence of a male body can trigger some feminists. Whatever it is, however, in order for us to get "worked up" and discriminatory in our behavior to others, we have to distort our purpose. We have to buy into the sort of hierarchical nondynamic dualism that won't let any of us be spiritually free.

The "goal" is not to be the ultimate Chicana or Jew or tribal member or anarchist. My being Chicana is my path to being ultimately One. Returning to my history, piece by piece, is my path to finding alternative faces through which I, as a human being, can see *Ometeotl,* the Divine One—God or Goddess. So when I deconstruct the practices and identities that have not led me there, I can *reconstruct* practices that will and do. And some of those practices may even come from traditions that my ancestry can not be linked to consciously. The One is far greater than genealogy.

Maybe this is disappointing to some. To think that ultimately we are actually "more" than Chicana or Chicano. To think that the tribe with which we identify is not the ultimate and only truth for us. It's not about "more" or "less," however. It's not that kind of journey. We're not *conquistadores,* trying to acquire power and personal wealth by taking it from others. If we surrender our boundaries, we do not lose anything. And if we allow others flexibility with theirs, no one loses. There is no rationing. "It" will never run out. But to those who enjoy playing "king of the hill," even in the name of rejecting oppression, well, maybe it is disappointing to realize that part of the game is surrendering the illusion that one day "we" will be the "ones" with "power," or that "we" have the "only" secret. The truth of the matter is that there *is* no secret. We all have power *right now:* real power. We just need to know how to get in touch with it. Realizing we are not bound by anything we have been told or believed is real. "Projects of possibilities" is what one of my students called this.

That's what being *Chicana* is for me. I was born *me*—with a social, historical, cultural, and political context. This is part of what my friend Connie Kaplan calls my "soul contract." I believe the fact that I am of Mexica ancestry is really important. It's the nonwestern part of me, the "Indian" or native American. But the minute I identify solely with this, I am eliminating divine tension. Because I am also of Spanish ancestry, of Basque, and I am a Jew. I live in the United States of America, during the postmodern era, with nieces and nephews of British and Scottish ancestry. They are Chicanas and Chicanos, too—all of that. *Chicana.* Earthquake. Volcano. Of the earth—this tension.

I accept the invitation
to eat the sacred mushroom
That I might forget
all that has been and will be
Giving my heart to Tonantzin
Divine Mother
Trusting.

Second Prayer to *Nuestra Señora de Guadalupe*

Señora, estoy confundida. I pray to you, the Mother that exists within your image, and ask that you help me to understand all that makes no sense about the way that we, your children, have been made to live in this world.

I call you Guadalupe because that is what we were told to call you, but I ask you, *madre,* to help me to know you from the depths of my heart and not from what I have been told to know.

Who am I, *Madre? Quienes somos, nosotros tus hijos y tus hijas?*

I pray to you with all of my heart, to help me understand the confusion of identity that this new world created for us. Show me how to recognize my heart that I might know how to offer it to you. Help me to avoid the altars that seek my heart for a false god. Bless me with the wisdom you hold that I might honor the truth that comes from all that is natural—teach me how to hear the truth in the words that I hear.

Show me the face I must wear and the dance I must do to fulfill my purpose on this sacred ground. Help me to hear your song and to smell your flowers that my heart and mind might keep me in balance in all I do. Help me never to be drawn to lies out of fear or respect for false authority.

Así es.

Part III

The Return Home

9

Reflections on the Journeys

looking into the obsidian glass
the darkness hiding what I see
looking with the inner eye
remembering all that I've let go

the echoes of my life
blend in a cacophonous chorus of angst
in loud waves of mocking laughter
¿quien eres?
¿crees que has cambiado?
just who do you think you're fooling
with your veiled nakedness,
María?

This deconstructionist dance leaves the dancer in pieces. And if I stop dancing now, that is how I will remain. My task is to trust that there is a power—a generative, creative power—I have called Mother that will show me how to be whole from these pieces.

I heard the teacher Osho say that there was a Zen tradition in Japan of breaking one's cup and mending it before using it—that there was no joy in a piece of art that was not unique in its brokenness. I guess the trick is in knowing how to mend it so the tea doesn't pour out through the cracks.

I think this is where I find myself now … wondering how this mending will happen, struggling to admit that this process of an embodied rosary of five

journeys has left me shattered, broken, aware of the ambiguity of my existence. Before, I was an entitled victim—the things I suffered were "their" fault, or the result of some life experience I'd chanced upon. I could psychologize and explain, attempt to rationalize my approach to coping. Now, I see a kaleidoscope of many colored pieces of my life, spinning, changing, sharing beauty that cannot be held for long, that will not let me stop spinning.

One of the faces of the divine feminine in the Aztec tradition is that of Tlacolteutl. She's the devourer of filth—the goddess of carnal lust. She is the patroness of these five journeys, I believe. It is her role to draw us to all the temptations and weaknesses and delights in our carnal life, to bring us to the epitome of the meaninglessness of everything we do. It is her role, as our caring Mother, to make us hate her, to cry out in agony, wondering why we exist. And when we finally fall apart, fall completely apart, it is her role to be there as the One eternal source of love and healing, to aid us in birthing ourselves anew. Donald Lewis describes her as:

> "Refuse Eater" because this Aztec Crone Goddess has as one of Her chief characteristics the quality of consuming outmoded forms and transmuting them. At the end of their life, each Aztec could make a confession to Tlacolteutl, Who would cleanse their soul of any wrongdoing which they related, allowing them to enter the Otherworld without regret As a Goddess of Death, Tlacolteutl is sometimes portrayed as an old woman, but She also has aspects as Maiden and Mother Goddess and so is sometimes portrayed as a seductive beauty. The most famous image of Tlacolteutl shows Her in the act of giving birth. (2001)

Traveling through the narratives of one's life, exploring the images and historical and cultural figures who have typified each of the five journeys, and daring to rip through propriety and decorum to be ruthlessly honest about them, is the confession to Tlacolteutl. Our birthing is our act of dying to who we think we are—to the outmoded forms of being.

I feel like the breath before speech, like the Hebrew letter Aleph, like the Fool in the tarot, like a snake who has slithered out of her skin and has not yet become comfortable in the new. The habituated patterns of the old lives call me, and I sense that it would not be difficult to heed their call, to return to the old ways. But like the grotesque ritual of my Aztec ancestors, in which they would literally skin someone and slide naked into the skin of another being, returning to my previous skin would be a horrific act, temporary at best, and would bring pain.

Why would I want to invite others to join me in finding their own journeys into the mysteries? Why would I be led to do this kind of work with others, helping them to uncover their lives' façades, to rip off the masks and to dance naked, without assistance from another? I don't know.

What I do know, however, is that even in the midst of the challenges of my life now, I do not ever wonder who I am. I do not ever long for home. Even when living in places I find inhospitable or uninviting, I am right at home. I do not ever wonder when I will become what I am meant to be. I know now that the difficulties I encounter along life's paths are the features of being alive, not of being punished or kept from some idyllic utopian life that I'm missing out on. I have come to a place of living that is more animalistic than any I'd known when I thought that to be human was to be separate from the earth. And it's not easier to live this way. In some ways, the illusions sustain our human motivations.

At any moment, the earth beneath my feet could heave and send everything around me shaking and crumbling to the ground. The trees could catch fire and the wind could send it burning through what we call home. Our sources of electric power could go out and we would be faced with the natural darkness that we have denied ourselves for a century. This tension is what it is to be alive—to know I could be eaten alive, burned to a crisp, and drowned in the waves of living water.

I believe that, being human, we are uniquely capable of being aware of these dangers while we go about our life's work and that the gift of the mysteries is the invitation to keep alive this awareness while drawing on the protecting, soothing power of the Father and the nurturing, creative power of the Mother. It is all magic. It is all divine. I understand the placid smile of the image of Our Lady of the Sacred Heart now—while a tear runs down her face and her heart is consumed by pain and flames. It's not about denying. It's about seeing. Feeling. Breathing in the air of what it is to be alive. And I also understand the absence of she whom I called *Nuestra Señora de los Remedios,* Our Lady of Remedies. Cutting the umbilical cord means living through the implications of my choices, even when I am blind to the damage that I am doing. It is a wake-up call to pay attention, to realize that I have power to do great harm as well as great good with what I create.

Now, when I make choices about what "I am," who I want "to be," I do so realizing that any choice that I make must be about being or doing that which keeps me alive to the tensions. Doing this project freed me of the confines of the Roman Catholic Church; I am no longer Catholic, and I feel no guilt or compulsion to answer to anyone for that absence of identification. Taking these journeys led me to embrace Judaism, to root myself in that faith while simultaneously honoring my Native American heritage and Chicana borderlands existence. These journeys threaten the security of my cultural and familial memberships, because I don't really believe I will ever make major life decisions based on the assumptions of group membership again. And it is still difficult to know how to feel when I feel as if I belong nowhere—but everywhere.

My relationships with men in my life have never been relationships in which I participated from my heart, from my essence. As long as my life's task was to

identify with authority and group memberships and to do what others wanted of me, I could not be in a divine union with another. I feel blessed for all the men I have loved and who have loved me, but I know I never really saw or let any of them touch my heart. Until now, that heart was always covered by a cloudy stain of who I thought I was, who I was trying to be. Only now is my heart open enough to love and be loved.

When I look at the way these journeys have reinvented the way I work and am, I realize that they did not reinvent anything. I have not reinvented anything. I have entered a way of life that is raw, terribly uncomfortable, full of ecstasy and passion, contradictions, and vulnerability. It is not reinvented; it has been revealed—by letting go of all I *thought* I had invented. I pray for my ability to keep living this way, to be led by the example of nature. And I am eternally grateful for the rosary I learned as a child, that I was able to deconstruct it and, from its beads, fashion the stepping stones along the journeys of the embodied mysteries of my life. Remember, María has spoken … and her name was never María. It is that way for all of us.

Notes

1. Jackie Martínez (2000) writes profoundly of this sort of interrogation of the self, and Bochner and Ellis (2002) have invited the dialogue on the therapeutic aspects of autoethnography.
2. The "human instrument" is a term used by Lincoln and Guba (1985) in their work, *Naturalistic Inquiry*. I adopt their term to mean that analogous to the pen-and-paper "instruments" of social science research, the human body/being must be consciously prepared and refined before engaging in the process of inquiry. The nature of one's findings is determined by this instrument. Taking care to prepare and know one's embodied self intimately is not an option; it is fundamental to the validity of one's work as an ethnographer.
3. I feel I should note here that—although I am writing about these practices and images here with specific emphases on women—due to their high cultural significance, they are also a predominant part of the experience of men of Mexican ancestry—albeit in ways complementary to gender roles. The interdependence of male and female roles is integral to any culture and, therefore, any truth regarding either males or females will have a complementary truth. Additionally, because of their deep rootedness in Roman Catholicism, many of the corresponding themes might also find application with individuals who are not of Mexican ancestry but who have been heavily schooled or socialized into a Roman Catholic way of experiencing meaning in one's life.
4. My performance in Florida is documented and discussed in Bochner and Ellis (2002).
5. I might add that Fox's interpretations of Eckhart's work and the implications for radical transformation of spirituality led to his work being proclaimed heretical by the Vatican, and his books are formally banned by the Catholic Church. See Fox's *Confessions: The Making of a Post-Denominational Priest* (1996).

Bibliography

Anderson, W. T. 1990. *Reality Isn't What It Used to Be.* San Francisco: HarperCollins.

Anzaldúa, G. 1987. *Borderland La Frontera: The New Mestiza.* San Francisco: Aunt Lute Book Company.

Balthazar, R. 1993. *Celebrate Native America! An Aztec Book of Days.* Santa Fe, NM: Five Flower Press.

Barabas, A. M. 1987. *Utopias Indias.* México: Editorial Grijalbo, S.A.

Benítez, F. 1991. *Los Primeros Mexicanos.* México: Biblioteca Era.

Bochner, A. P., and Ellis, C., eds. 2002. *Ethnographically Speaking.* Walnut Creek, CA: Altamira Press.

De la Garza, S. A. 2003. "An Ethics for Postcolonial Ethnography," in Clair, R. (ed.) *Expressions of Ethnography.* Albany, NY: SUNY Press.

Díaz de Castillo, B. 1992. *Historia Verdadera de la Conquista de la Nueva España.* México: Editores Mexicanos Unidos, S.A.

Easwaran, E. 1989. *Original Goodness.* Berkeley, CA: Nilgiri Press.

Foucault, M. 1972. *The Archaeology of Knowledge.* New York: Pantheon.

Fox, M. 1980. *Breakthrough: Meister Eckhart's Creation Spirituality in New Translation.* New York: Doubleday.

———. 1983. *Original Blessing.* Santa Fe, NM: Bear and Company.

———. 1994. *The Reinvention of Work.* San Francisco: HarperCollins.

———. 1995. *Wrestling with the Prophets.* San Francisco: HarperCollins.

———. 1996. *Confessions: The Making of a Post-Denominational Priest.* San Francisco: HarperCollins.

Ginsburgh, Y. 1991. *The Alef-Beit: Jewish Thought Revealed Through the Hebrew Letters.* Northvale, NJ: Jason Aronson.

Glaser, B. G. 1978. *Theoretical Sensitivity: Advances in the Methodology of Grounded Theory.* Mill Valley, CA: Sociology Press.

Glaser, B. G., and Strauss, A. L. 1967. *Discovery of Grounded Theory: Strategies for Qualitative Research.* New York: Aldine de Gruyter.

González, M. C. 1998. "Painting the White Face Red: Intercultural Contact Presented Through Poetic Ethnography," in Martin, J., Nakayama, T., and Flores, L. (eds.) *Readings in Cultural Contexts.* Mountain View, CA: Mayfield Publishing.

———. 2000. "The Four Seasons of Ethnography: A Creation-Centered Ontology for Ethnography," *International Journal of Intercultural Relations,* 24, 623–650.

———. 2003. "Ethnography as Spiritual Practice: A Change in the Taken for Granted (or an Epistemological Break with Science)," in Glenn, P., LeBaron, C., & Mandelbaum, J. (eds.) *Studies in Language and Social Interaction.* Mahwah, NJ: Lawrence Erlbaum Associates.

Goodall, H. L. Jr. 1991. *Living in the Rock and Roll Mystery.* Carbondale: Southern Illinois University Press.

Harvey, A. 1994. *The Way of Passion.* Berkeley, CA: North Atlantic Books.

Kamenetz, R. 1997. *Stalking Elijah.* San Francisco: HarperCollins.

La Otra Conquista. 1999. 35 mm, 2 hrs. Los Angeles: Domínguez and Carrasco Films.

Lewis, D. 2001. *God of the Month: The Crone-Tlacolteutl.* www.telepathicmedia.com.

Lincoln, Y., and Guba, E. G. 1985. *Naturalistic Inquiry.* Newbury Park, CA: Sage Publications.

Martínez, J. M. 2000. *Phenomenology of Chicana Experience and Identity.* New York: Rowman and Littlefield.

Mini, J. 2000. *The Aztec Virgin.* Sausalito, CA: Trans-Hyperborean Institute of Science.

Ortega, S. 1985. *De La Santidad a La Perversión.* México: Editorial Grijalbo, S.A.

Paz, O. 1959. *El Laberinto de la Soledad* (The Labyrinth of Solitude). México: Fondo de Cultura Económica.

Rodríguez, J. 1994. *Our Lady of Guadalupe: Faith and Empowerment Among Mexican-American Women.* Austin: University of Texas Press.

Taylor, J. 1998. *The Living Labyrinth.* Mahwah, NJ: Paulist Press.

Valentine, K. B. & Valentine, D. E. 1983. "Facilitation of Intercultural Communication Through Performed Literature," *Communication Education, 32,* 303–306.

Van Maanen, J. 1988. *Tales of the Field.* Chicago: Univ. of Chicago Press.

Watzlawick, P. 1993. *The Language of Change: Elements of Therapeutic Communication.* New York: W.W. Norton.

Watzlawick, P., Beavin, J., & Jackson, D. 1967. *Pragmatics of Human Communication.* New York: W.W. Norton.

Index